Design and Colour in Watercolour

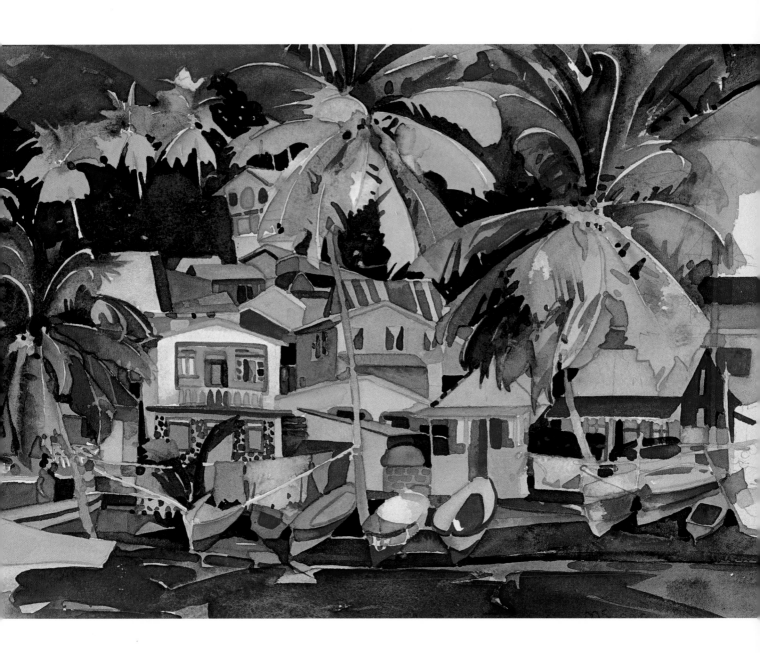

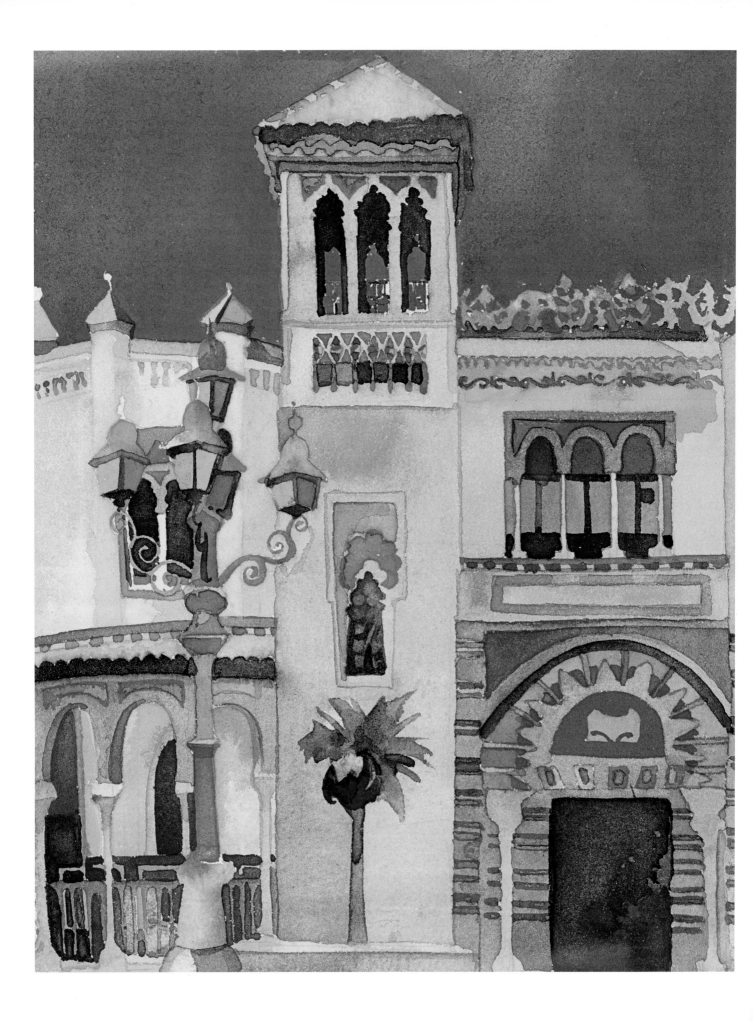

Design and Colour in Watercolour

Michelle Scragg with Robin Capon

BATSFORD

For my daughter Sergienna and my nephew Ryan Barsby, who just love drawing.

Acknowledgements

A big thanks to Robin Capon, whose skill with the written word made all my anxieties evaporate when compiling this book. His professional help made this project a most enjoyable experience.

I would also like to pay tribute to my late father, John Scragg, whose patience, perseverance and support for my chosen career as an artist never diminished. Thank you to my husband Junie, who believes in what I do, and to my sister Amelia and her husband David, and friends Caroline Rees, Deirdre Traynor and Claire Harrigan, for listening with sympathy to my exhausting whines about the creative process.

My paintings have grown larger over recent years and I simply could not have contemplated work on this scale without the expertise of my faithful framer, Vernon Hill. Thank you to him for the last eleven years.

Michelle Scragg
www.michellescragg.co.uk
www.sittingcolour.co.uk

First published in the United Kingdom in 2009 by
Batsford
10 Southcombe Street
London
W14 0RA

An imprint of Anova Books Company Ltd

ISBN 978 1 9063 8804 1

A CIP catalogue record for this book is available from the British Library.

16 15 14 13 12 11 10 09 08
10 9 8 7 6 5 4 3 2 1

Reproduction by Rival Colour Ltd, UK
Printed and bound by Craft Print Ltd, Singapore

This book can be ordered direct from the publisher at the website: www.anovabooks.com, or try your local bookshop.

Caribbean Coast (page 1)
25.5 x 35.5 cm (10 x 14 in)

Art Museum, Seville (page 2)
25.5 x 15 cm (10 x 6 in)

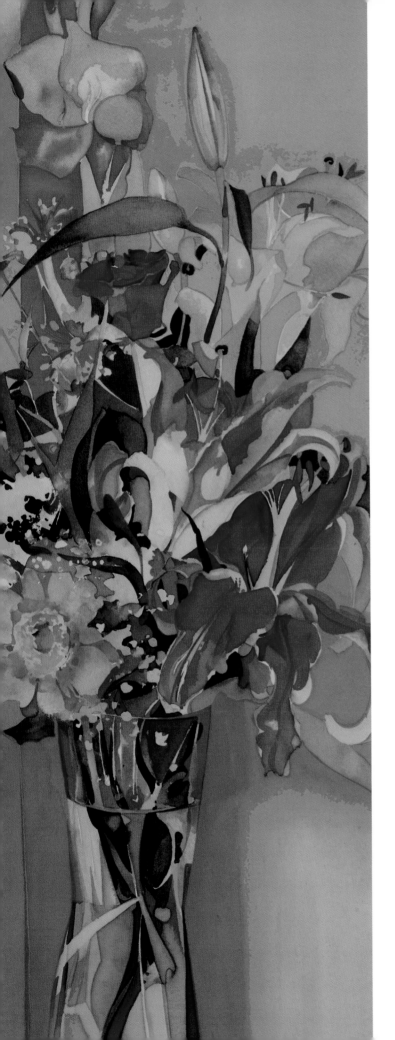

CONTENTS

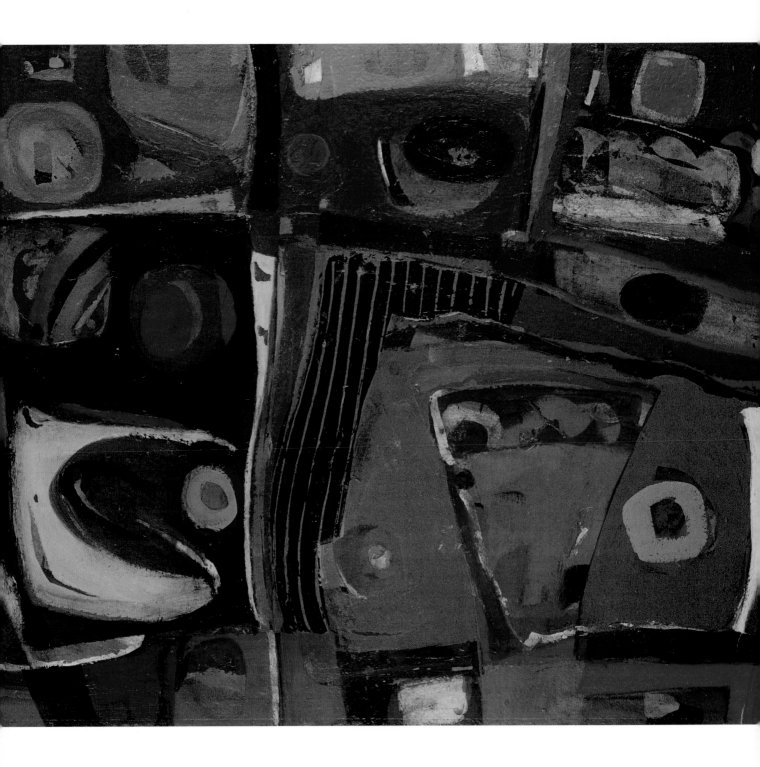

Introduction

Drawing and painting have always been a big part of my life. When I was three, all I ever wanted to do was draw. As I grew older, I became interested in looking at paintings, although not necessarily understanding what I saw. I particularly loved Walt Disney cartoons and *The Beano* comic, and I was mesmerized by the powerful colour in Disney films.

Later, in my teens, I went on a school trip to London and saw my first major exhibition – stunning impressionist paintings by Degas. Since then, various exhibitions, especially those featuring Gauguin, the 'Glasgow Boys', Mark Rothko, Egon Schiele, the Japanese Edo period, Otto Dix and Patrick Heron, have helped shape and challenge my approach to painting.

For me, art school was like a love affair: it was a strange, bewildering, hard, engaging and totally exciting experience. I wanted to paint all day long, but I was well aware that I would have to make a living after art school. The Department of Printed Textiles, in which I was a student, gave me the opportunity to work with paints, but also taught me other technical processes, such as photography and all types of printing. Perhaps most importantly, it taught me the disciplines of good design.

Polemo
watercolour and acrylic
76 x 56 cm (30 x 22 in)
Even though I am now focusing more on abstract paintings, I normally start with watercolour, before introducing acrylic colours to achieve a greater variety of effects.

Michelle Scragg in her studio.

When I finished my course, I was torn between fine art and commercial art and design. I found it hard to separate the two, and I still do. However, I was very lucky to be offered a job by Osborne & Little, a company that specialized in printed fabrics and furnishings. It was a wonderful opportunity for me to develop my skills as a fabric colourist, working on ideas for fabric collections and wallpaper. It was this experience that gave me a real insight into the way colour works.

After two years of working as a designer by day and painting my own watercolours at night, I decided to focus completely on painting. Fortunately, over the next ten years, I was able to earn enough money from my paintings to enable me to travel a great deal, and so develop my knowledge and understanding of watercolour.

What I discovered was that watercolour is a fantastic medium for creating bold colour and rich tonal diversity. Equally, it encourages and demands drawing skills, and it sharpens your own sense of style. Moreover, there are no half-measures with watercolour: you have to commit to the marks that you make, for it is not easy to alter anything. But if the marks are right, there is a freshness and purity of colour and a spontaneity of technique that is difficult to rival in any other medium.

This book has given me the opportunity to share with others my approach to watercolour and in particular my love of colour and design. For me, colour is virtually always the inspiration for a painting, and I am a firm believer in the importance of sound drawing and design as an underpinning for each image. This is the essential message of this book, and with detailed information and the help of numerous finished as well as step-by-step paintings, I hope I can encourage more artists to be adventurous with colour, and indeed more adventurous with the watercolour medium itself. It is a much more versatile medium than most people realize.

Being a full-time professional artist involves a lot of demands and sacrifices; however, the sense of achievement in finishing a successful painting is very rewarding. Painting is something that I must do; I have no doubt that a life without the opportunity to express ideas through the use of colour would be miserable and unfulfilled.

Recently I have begun to concentrate more on abstract colour compositions that start with a watercolour sketch but are then developed much further, using oils or acrylic colours. Each one takes weeks to finish and proves to be a real roller-coaster ride as far as my emotional and physical strength are concerned. I cannot move on to something else until I have reached a satisfactory conclusion with each image, this being the moment when colour, space and shape seem to fit perfectly with each other.

But now, to find that these abstract paintings can be adapted as designs for furnishing fabrics, which can subsequently be used to upholster carefully chosen pieces of furniture, has introduced a completely new challenge. I now have to think in terms of three-dimensional forms – and all thanks to the versatility of watercolour!

Portuguese Fishermen
watercolour
10 x 15 cm (4 x 6 in)
Colour is usually the most important quality that I want to explore in a painting, and for me watercolour has always been an incredibly rewarding medium to use.

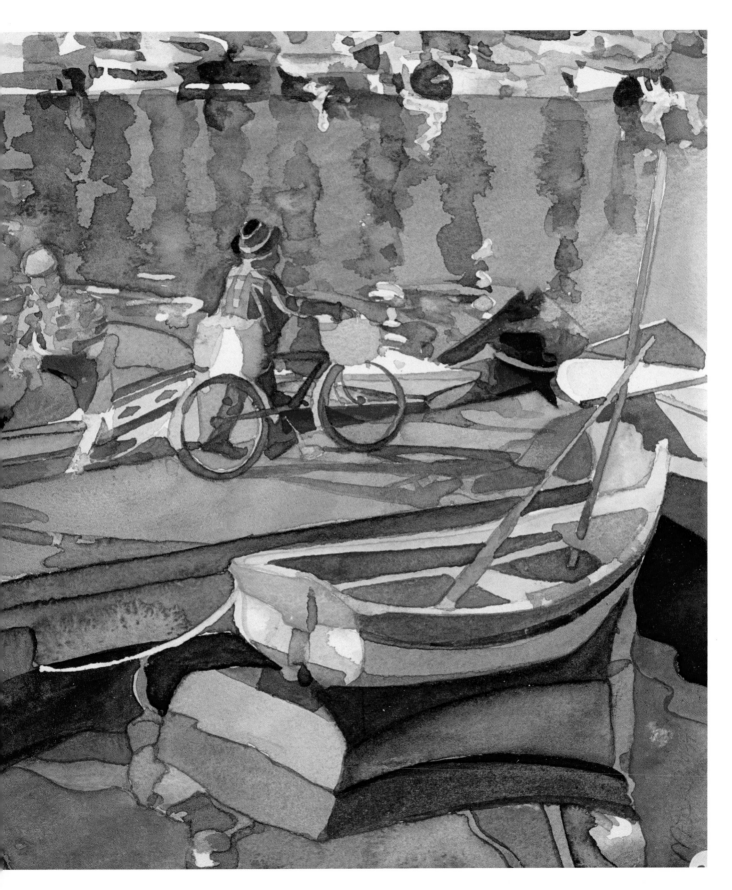

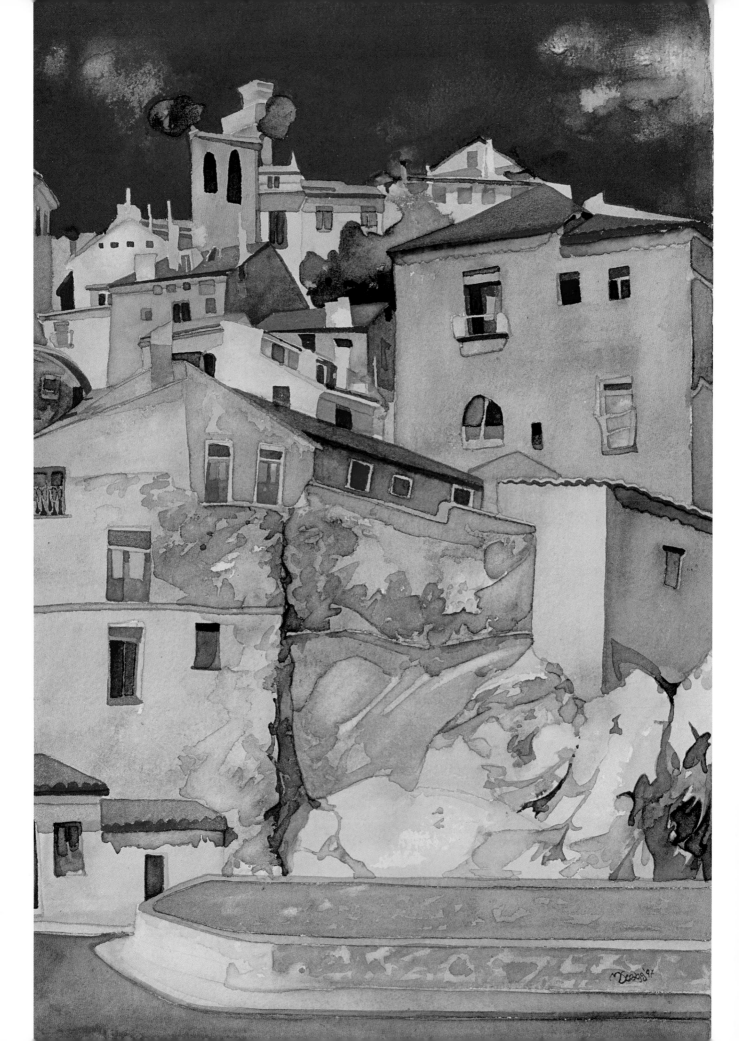

Exploring Watercolour's Strengths

1

For many artists, the attraction of watercolour lies in its wonderfully fluid nature and the fact that it can be applied as sequential washes of colour to create subtle atmospheric and translucent effects. Essentially this is the traditional approach to watercolour painting – an approach that initially relies on reserving the lightest areas of the work (by leaving the paper unpainted) and then gradually building up the contrasts of colour and tone with a succession of colour washes. Therefore, when adopting this approach, the artist works from light to dark.

However, unlike most other painting media, in watercolour it is exceedingly difficult to retrieve highlights and other light areas and shapes once lost. Also, watercolour can easily become overworked and so lose its characteristic purity and vitality. Not surprisingly, these potential difficulties have led many people to assume that watercolour is an unpredictable and therefore unreliable medium to use.

Yet surely this is part of the joy and challenge of painting in watercolour, especially when it is handled in a free and expressive way. You can never be entirely confident about the outcome, although equally there is seldom a disconcerting loss of control. Moreover, if you need more control, there are other working methods that – with experience – will allow it, and so enable you to create exactly the effects and impact you have in mind for each painting. And this is one reason why I have always liked watercolour: I think it is an excellent medium for developing a personal means of expression. It is a much more versatile medium than at first seems possible.

Exciting Potential

Watercolour is generally associated with subtle colour and the fact that its impact relies on mood and suggestion rather than carefully organized elements and details. It is not usually thought of in terms of strong, lively colour and telling design. However, these are the qualities that I like to exploit in watercolour. For me, colour is virtually always the motivating force for a painting. What particularly excites

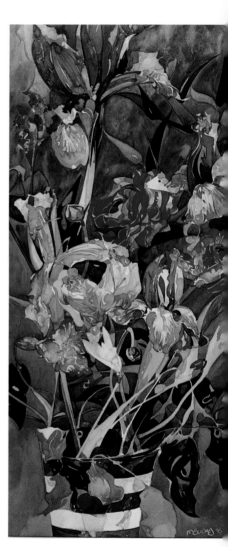

Irises
watercolour
122 x 51 cm (48 x 20 in)
As in this work, I like to exploit different colour relationships and tonal contrasts to create the most interest and impact from the subject matter.

Cuenca Hill
watercolour
76 x 61 cm (30 x 24 in)

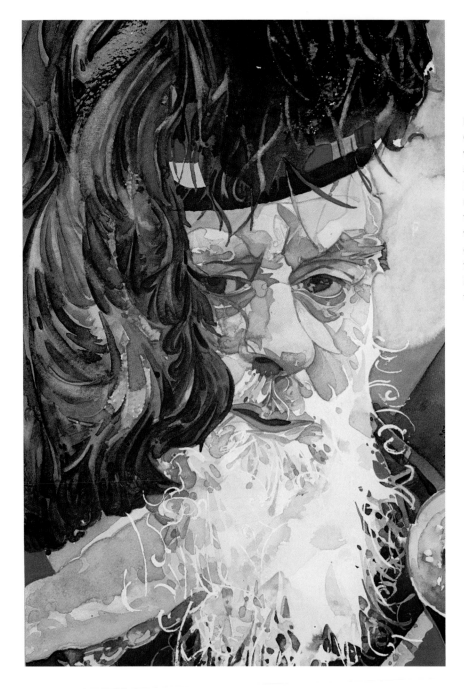

Ian Morrison, Lonach Gathering
watercolour
56 x 35.5 cm (22 x 14 in)
If you keep the colour mixes pure and ensure that the sequential washes are not overworked, you will find that watercolour is an excellent medium for portraits.

me, as in *Irises* (page 11), is the way that different colour relationships and tonal contrasts (the play of light and dark values within the colour palette) can add immense power to a design and create a result that is both visually and intellectually interesting and challenging.

My love of colour began when I was a student at the Glasgow School of Art. I think colour was always important to me, although at first I wasn't sure how to use it and express myself with it. At college, drawing was my main strength. However, during my second year I went to see an exhibition of work by the 'Glasgow Boys', which was on show at a gallery in the city. The collection of paintings included watercolours by Arthur Melville and Joseph Crawhill. I was overwhelmed by what I saw. I had never imagined that watercolour could be used with such power: I thought it was a very clever and exciting way of expressing colour. That experience completely changed my approach to my paintings. It gave me a new sense of focus and direction.

Self-expression

Fruit Bowl

watercolour

23 x 30.5 cm (9 x 12 in)
I never feel obliged to
interpret colours in a literal
way, as they actually
appear in the subject
matter. It is often
necessary to select and
exaggerate colours, I think.

Self-expression is everything in painting, I think. Each artist observes and responds to ideas differently, and it is important that this individual view of the world is reflected in his or her paintings. Ideally, paintings should demonstrate an emotional response and reveal something about the artist, as well as creating interest through subject matter, technique and formal elements. As in *Fruit Bowl* (below), even a well-tested theme such as a still life can convey tremendous vigour and originality if interpreted subjectively.

The essential point is to be true to yourself and focus on those features within the subject matter that you find exciting and inspirational. I paint a wide variety of subjects, but in fact it is not the particular landscape, still life or whatever that holds the principal appeal, but the potential for a composition in which the emphasis and drama will concern colour. I rarely seek out specific subjects. Rather, something will trigger my interest, and usually this is a certain quality of light or an exciting relationship of colours.

In the past, I have travelled to a number of locations where I thought the landscape would inspire ideas – the Caribbean, for example. But instead I found it was the people, and the

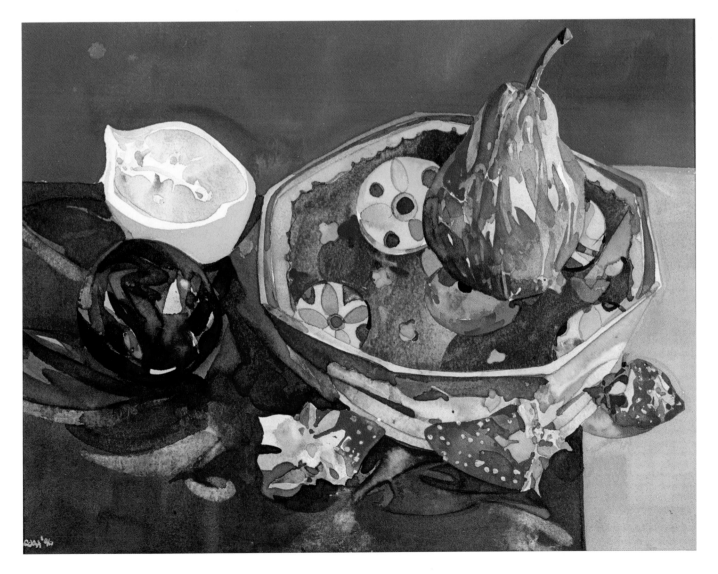

way they related to the landscape, that most interested me. My working method is to make notes and sketches, which frequently include a fairly involved watercolour sketch in which I will explore the potential for strong tonal contrasts. Even when I intend to work in oils or acrylics, I often start with a watercolour study, because this gives me the freedom to use strong colour. When painting in oils or acrylics, I think it is sometimes more difficult to keep a focus and at the same time maintain the spontaneity with colour. I find it easier to create a freshness and purity of colour with watercolour, and this in turn helps encourage a sense of direction with the work.

Paints and Other Materials

You can buy watercolour paints in square or oblong pans (half-pans or whole pans), which are small blocks of compacted dry or semi-moist colour, or you can choose tubes. I occasionally use pans when I am making a watercolour sketch on location; otherwise my preference is for tubes. With their moist, reasonably fluid consistency, tube colours are a more reliable choice for keeping colours pure and fresh. Pan colours, on the other hand, are more difficult to 'lift' and mix, and they can easily become contaminated by the surrounding colours in the paintbox. However, if you like working from a paintbox, my advice is either to buy an unfitted box and fill the divisions with tube colours, or to start with pan colours and, as required, refill the pans from tube colours.

I only use the best artist's quality colours, mainly from the Old Holland and Winsor & Newton ranges. Although I have some favourite

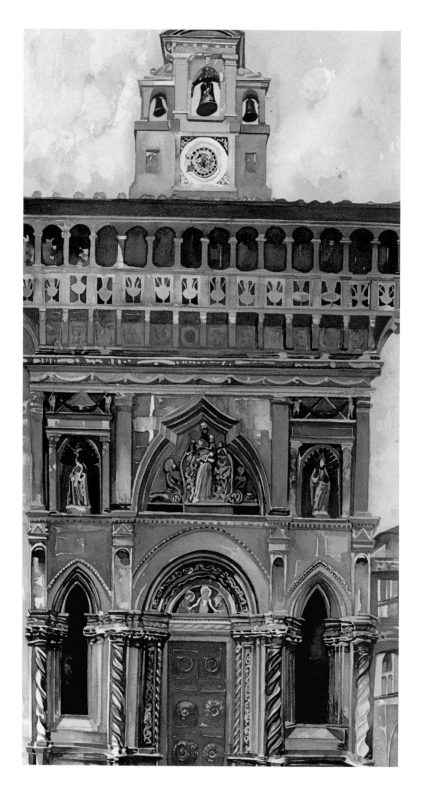

Italian Façade
watercolour
76 x 43 cm (30 x 17 in)
A key point, with any subject matter, is to concentrate on the aspects that most impress you. Occasionally, as here, some subjects encourage more attention to detail, but this is not an approach that I would normally adopt.

Trio Goldfish

watercolour

33 x 25.5 cm (13 x 10 in)
Usually, I prefer to paint on
heavy-quality textured paper,
which has the advantage that
it does not need stretching
and will take quite vigorous
treatment.

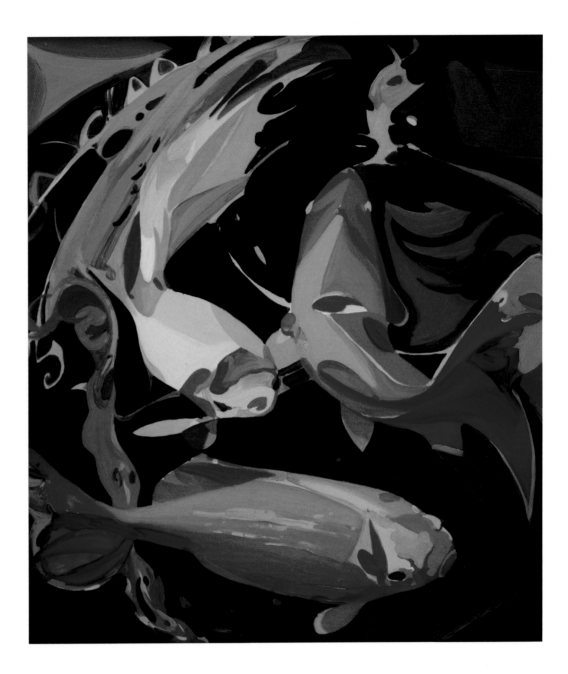

colours, I do not work from a set palette. Rather, the choice is determined by a number of factors, using the colours within the subject matter as a starting point and responding to the mood and colour relationships I have in mind for the painting.

I use large, white ceramic plates as mixing palettes, with a different one for each colour range. So, I have all the reds on one palette, all the blues on another, and so on. Again, this helps to keep the colour mixes pure, and I can achieve effects like those shown in *Trio Goldfish* (above). I replenish each colour when necessary, always keeping the central mixing area clean. Every few days, I clean the entire palette and start again with fresh colours.

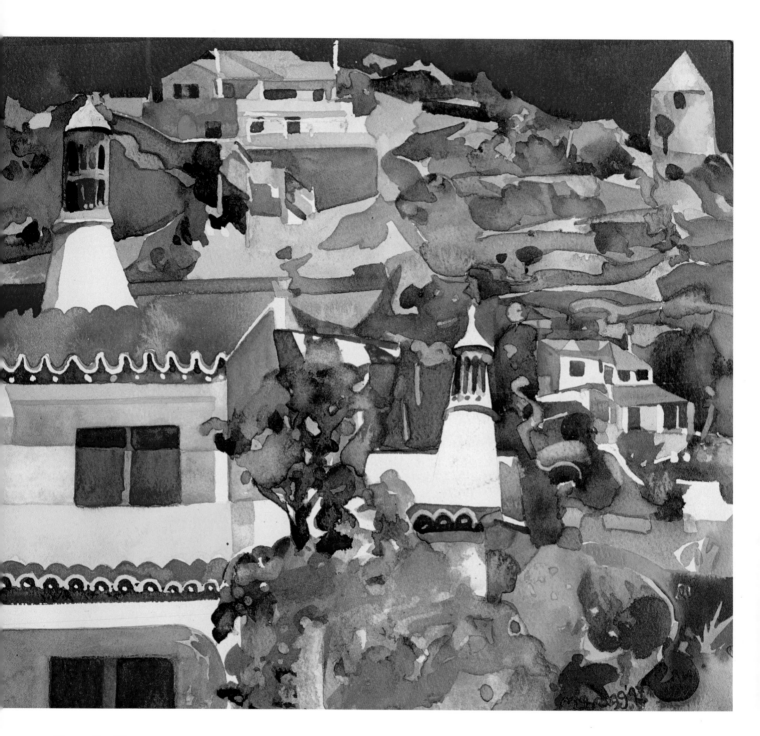

Algarve Roof Tops
watercolour
35.5 x 46 cm (14 x 18 in)
I never work from a set palette
of colours. Each subject matter
suggests a particular set of
colour relationships, and so I
choose my colours accordingly.

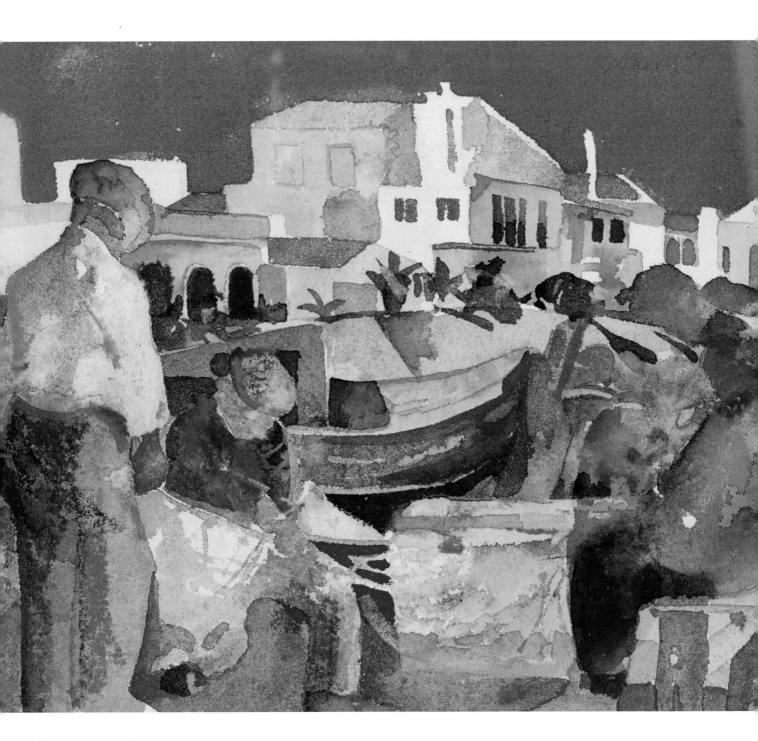

Net Mending, Portugal
watercolour
20.5 x 25.5 cm (8 x 10 in)
I deliberately chose a sheet of unsized
watercolour paper for this painting, so
that the shapes would have a slightly
less defined quality.

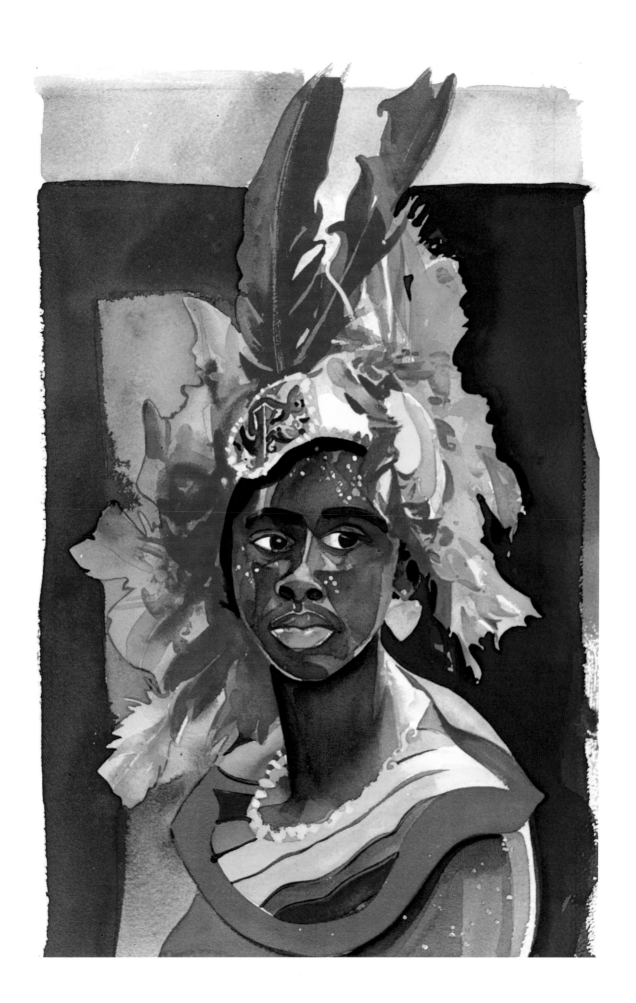

Brushes

There is a tremendous variety of brushes available and obviously it is important to find the types and sizes that best suit your style of work and the sort of techniques you prefer. This will probably mean experimenting to start with, until you find a range of brushes that you are happy with.

I prefer long-handled brushes and my favourites include Winsor & Newton Cotman Series 444 round, pointed brushes, which are both versatile and hard-wearing. Essentially I need brushes that will keep a good shape and point. My choice also includes a lot of inexpensive brushes, which may last only a few days, as well as the best kolinsky sables, decorators' brushes and various other types, including flat wash brushes.

Paper

Thin watercolour papers should be avoided, as they may distort the marks and effects you make. Mostly I choose a heavy-quality textured paper, such as Arches Aquarelle 850gsm (400lb) Rough, which is sold in 56 x 76cm (22 x 30in) sheets. Unfortunately it is not available in larger sizes, so if I want to work on a bigger scale, I have to choose a less weighty paper: Saunders Waterford 640gsm (300lb) Rough, which is available in sizes up to 101 x 152cm (40 x 60in).

I always used to stretch the paper, but with the Arches heavy-quality paper there is no need. Another advantage is that it will stand up to quite vigorous treatment in the way that paint is applied and in the use of different techniques, such as working with masking fluid or lifting out colours. The scale of my paintings varies and ideally I like to work on a sheet of paper that is sufficiently large for the painting to develop naturally and find its own size.

Masking Fluid

When, at art college, my work underwent a radical change and I started to explore the potential of watercolour, I soon discovered masking fluid, which I found was a liberating and exciting substance to use with watercolour techniques. It is now an essential part of my working process.

If you haven't worked with masking fluid before, give it a try, because it will dramatically increase the range of surface and colour effects that are possible. Masking fluid is a rubber compound solution, which you can paint on to particular areas to prevent them accepting subsequent colour washes. It is often used to 'save' highlights, fine lines and small details within an area that is going to be treated with a general wash, and it can be applied to both the white paper and over dry colour. It dries to form a thin film, and when required it can be rubbed off and any necessary modifications made to the area underneath.

For me, in every painting there is a 'special' area that I have to preserve, irrespective of what happens in the rest of the painting. I find this is true with both the more conventional designs and the abstracts, and even the work that I do in acrylics. It might be simply a small patch of colour or perhaps just a pink line, but I keep that area completely protected with masking fluid until the end. Then I rub off the masking fluid and, if necessary, use a small brush to adjust the tone or colour of the area that has been protected. Perhaps it is too white, for example, in relation to the surrounding area.

With the large abstract paintings, I sometimes pour on a whole bottle of masking fluid and work this across parts of the surface using a large household paintbrush. When this is eventually removed, it adds a surprising vigour to the design and in general helps with the spontaneity and sharpness of colour that I always seek.

Carnival
watercolour
66 x 35.5 cm (26 x 14 in)
Masking fluid adds to the freedom of the working process. As here, I often use it to preserve highlights and other 'special' areas of a painting while I am building up washes of colour.

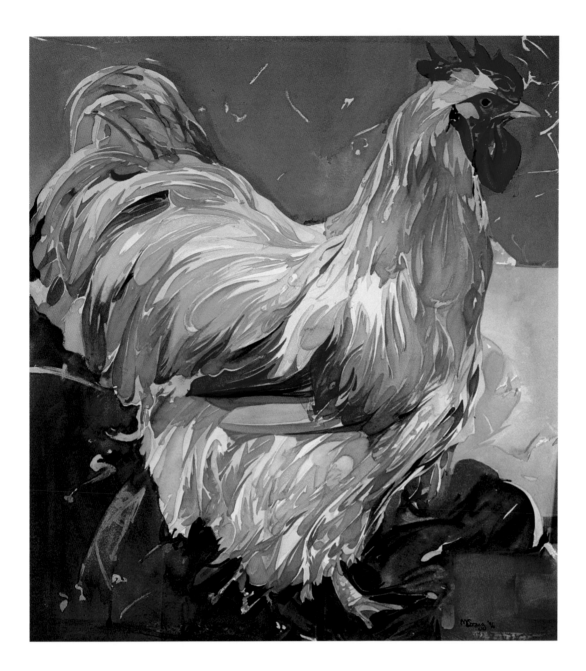

Skills and Techniques

In watercolour painting, as in any medium, the development of skills relies on a willingness to practise and experiment. It is only by working with paint and testing out different techniques and effects that you acquire an awareness of which methods are the most appropriate for you, and which should be avoided. Sensitivity for the medium, and the general way that it is used, obviously vary from one artist to another.

In my opinion, the most important skills to develop are those of establishing a reasonable degree of confidence and control with the medium and, equally essentially, being able to keep the colours clean. With both of these points, the way that you set out your colours on a palette or in a paintbox, and the methods you use for mixing colours, are influential factors. As I have explained (see page 15), I prefer to use separate palettes for each colour range, and I clean the palettes quite frequently. Additionally, when I am mixing colours, I try to keep the number of colours involved to a minimum, because this is another way of avoiding muddy colours. And, of course, it is also important to work with clean brushes and water.

Red Cockerel
watercolour
91.5 x 81 cm (36 x 32 in)
A successful watercolour relies on keeping the colours clean and working with as much confidence and control as possible.

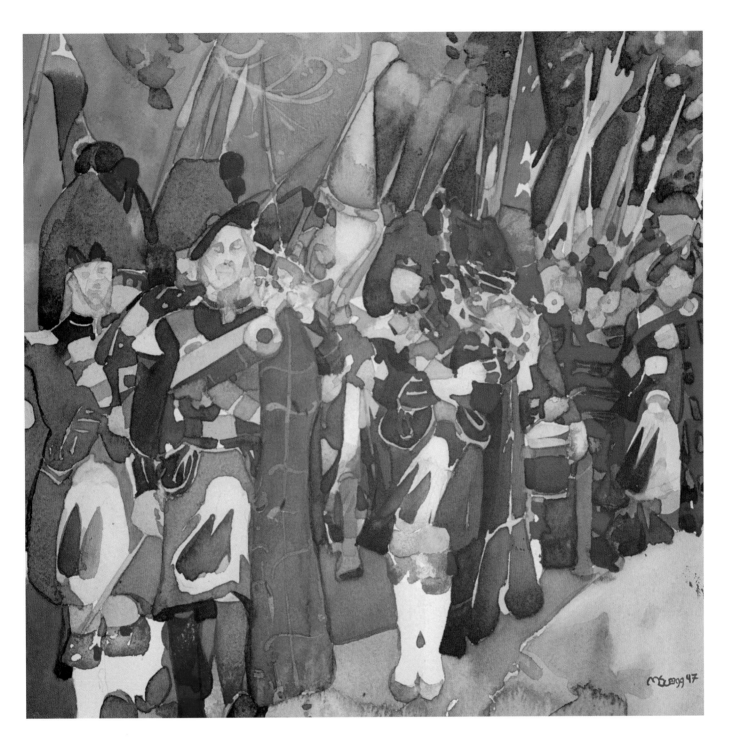

Developing Confidence

The March
watercolour
30.5 x 35.5 cm (12 x 14 in)
A sound drawing is the first
essential step for every
painting, and particularly
with figurative subjects.

In a painting such as *The March* (above), you can see how much my technique relies on sound drawing and a confident use of colour. The strength of the individual colours and the intensity of the tonal contrast throughout this painting were achieved by working with a succession of colour washes, layer over layer, until the desired effect was reached. Confidence comes from experience, and consequently the ability to work with a consideration and understanding for the whole painting – realizing the implications when colours are added or shapes altered, for example.

Confidence also encourages an evolving style of work, I think. My work has changed in various ways during my career: I have painted in different media, with an increasing emphasis

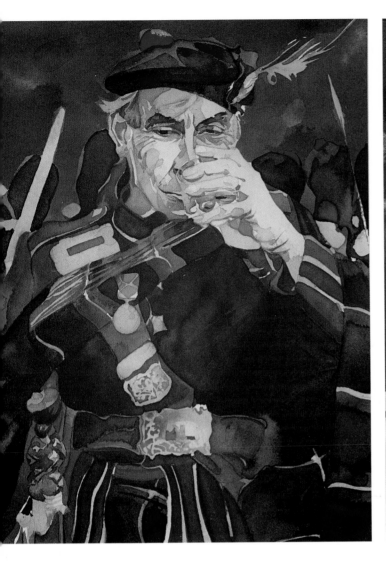

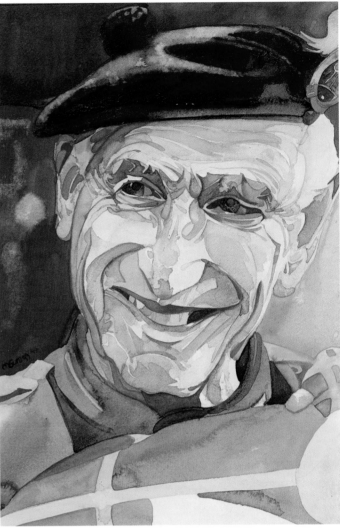

on exploring scale and colour. Currently I am mainly working on a series of large-scale acrylic paintings, but applying some of the techniques that I have developed for watercolours, particularly the use of masking fluid to exploit incidental effects. The aim in all my paintings is for a journey of colour, and essentially each finished work is a statement of colour.

Sequential Washes

Watercolour can be mixed and applied in a fairly thick consistency (in which case the colour will be opaque rather than translucent), but for most artists, and especially those who like to work in the traditional way, the preferred technique is to build up effects using a sequence of colour washes. The more washes that are applied, the darker the tone or the richer the colour becomes. In this context, a wash means colour pigment mixed with a generous amount of water.

The character of a colour wash – the way that it dries and the effect that it creates – depends on a number of factors. These include the choice of paper and whether the surface is dry or damp (by wetting it with a sponge and some water); the type of brush or sponge used to apply the wash; and the technique of applying the wash – for example it could be quite a controlled method or a much freer, expressive technique.

The Dram (above left)
watercolour
46 x 30.5 cm (18 x 12 in)
In this painting you can see how the intensity of the dark tones has been built up with a succession of colour washes, layer over layer.

Head of the Forbes Clan
(above right)
watercolour
56 x 35.5 cm (22 x 14 in)
By slightly dampening the paper, you can create more subtle tones from which to develop the painting.

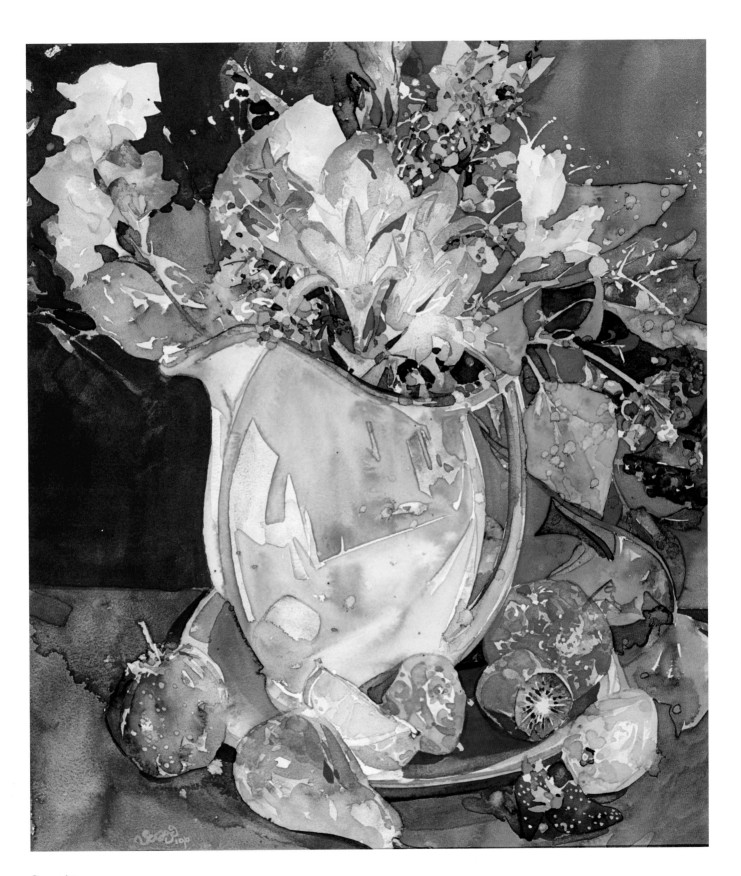

Green Jug
watercolour
81 x 66 cm (32 x 26 in)
As here, I usually like to work with
clearly defined areas of colour.

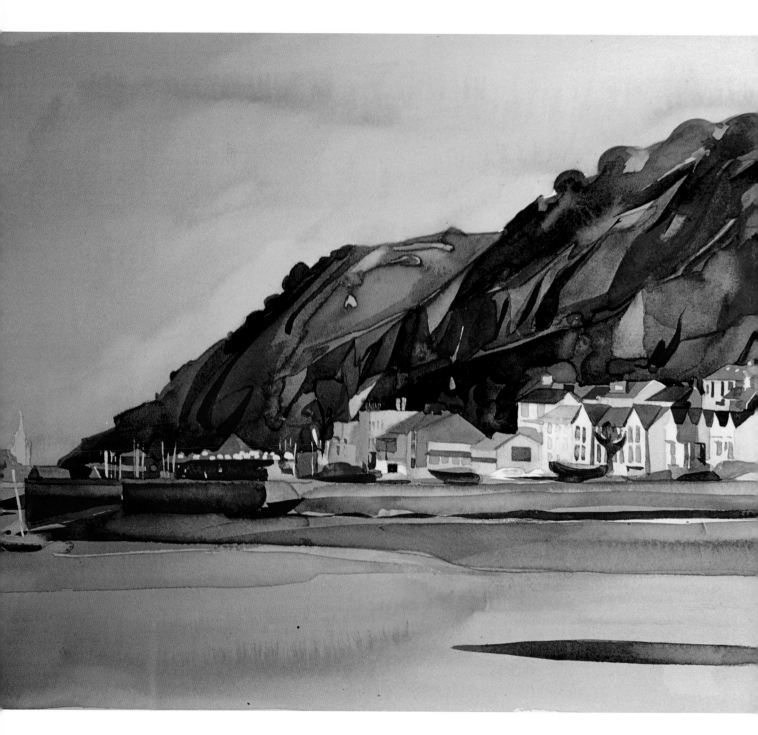

You will notice in my watercolours that generally the shapes are clearly defined and the colours crisp and bright. Look at *Green Jug* (page 23), for example. The initial washes for a painting such as this are very controlled blocks of flat colour. These blocks or shapes are carefully considered and essentially they form the basic drawing and design of the work. For me, the drawing and the first colour washes are integral to each other. From the very beginning I think in terms of complete coloured shapes and their relationships to one another, rather than starting with outlines to indicate shapes.

Towards the end of a painting, as I begin to think more about the surface quality of different objects, having now established their basic form and character with the sequence

Mumbles Front
watercolour
38 x 101.5 cm (15 x 40 in)
Sometimes, working with patches of colour applied wet-against-wet can be a very effective technique – for example in suggesting the wooded hillside area in this landscape subject.

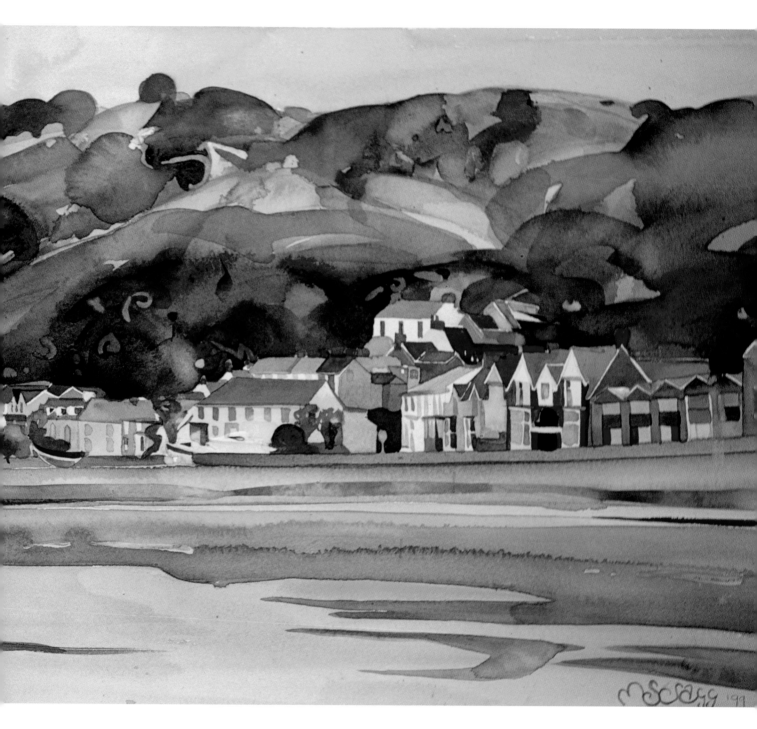

of colour washes, I may use other wash techniques, such as graduated or variegated washes (see below). Again, there is evidence of these techniques in some of the fruit and flower shapes in *Green Jug*.

A graduated wash is one in which the colour gradually changes from light to dark, or vice versa, and it is made by increasingly strengthening or weakening the colour wash as you apply each broad brushstroke or band of colour, working quickly, wet-against-wet. A variegated wash is made by using several colours that are allowed to run together, in a random or a deliberate way.

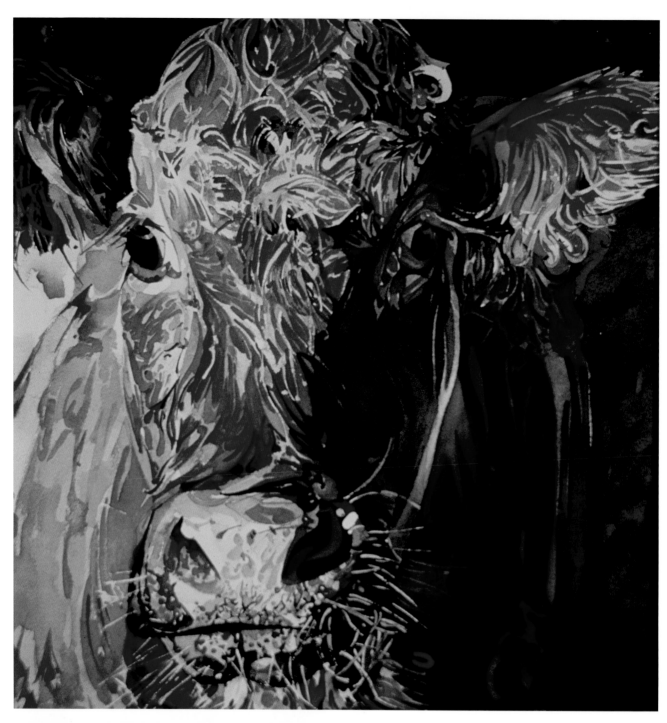

Family
watercolour
15 x 23 cm (6 x 9 in)
Choose wet-into-wet washes
when you want to add interest
with a broken-colour effect, as
in the background area of this
painting.

Adventurous Techniques

By applying colour to damp paper, or into or against other colours while they are still wet – a technique known as wet-into-wet – you can create an exciting fusion of colour with soft, diffused edges. I occasionally use this technique for small areas of texture or perhaps a broken colour effect in a background area, as in *Family* (opposite page, bottom), but mostly I prefer the more controlled approach of working wet-on-dry.

This technique works particularly well on a surface-sized paper, such as Arches Aquarelle, which is my preferred choice. Surface-sized papers hold the paint well and thus allow a good degree of control with the brushstrokes. With the wet-on-dry technique, as the name suggests, each layer of colour is allowed to dry before applying the next. When applying the successive washes you need to work confidently and swiftly, with broad, light brushstrokes, so that you avoid lifting or disturbing the colour from the previous layer. *Brown Cow* (opposite page, top) is an example of this controlled method of working.

For additional control, I use masking fluid to contain the colour washes, as explained on page 19. The masking fluid can be applied to delineate a particular shape – perhaps a petal shape in a flower study, for example – and thus restrict the colour wash to within certain bounds and create a flat area of colour with crisp, clearly defined edges. Alternatively, the shape itself can be masked out, so that it is protected from a more general adjacent or background wash application.

You may find that tinted masking fluid is more useful as it shows up much better than the off-white type. Masking fluid is not good for brushes, so it is advisable to use an old soft-haired brush rather than one of your most expensive ones. Some artists protect the brush by first dipping it into a weak solution of liquid soap. This has no effect on the masking fluid, but it makes cleaning the brush much easier.

Body Colour

When white paint is used to emphasize highlights or other light areas in a watercolour, or it is added to a colour mix, this is known as body colour. Chinese white watercolour, white gouache or acrylic paint, or even white ink can be used for this purpose. However, whether or not body colour is an appropriate technique depends on the type of painting and the sort of effects that you want to produce.

Personally, I love the transparency of watercolour and I prefer to reserve areas of white paper for highlights and similar effects, or I rely on the contrasts of tones and colours to suggest lights and darks. I sometimes add a touch of white to a colour mix if there is no other way of creating a certain colour, for example a pink. But otherwise I avoid body colour, because it would not be sympathetic to the way that I like to use watercolour. Also, of course, adding white will make the colour mixes opaque, which again is not a quality that I generally like to exploit in my watercolour paintings; however, see *Blue Floral* (right).

Brown Cow (left)
watercolour
68.5 x 51 cm (27 x 20 in)
When building up a depth of tone, as for the shadow area in this painting, use broad, light brushstrokes so that you avoid disturbing the colour from the previous layer.

Blue Floral (right)
watercolour
38 x 23 cm (15 x 9 in)
For a really bold and slightly textured white area, I sometimes use white gouache.

Lifting Out

There is something really lovely about a flat wash of colour, and usually this is the effect that I want to achieve. Nevertheless, there are times when the surface of something is more textural in appearance and therefore requires a different approach. Sometimes I work back into a colour wash whilst it is still damp and modify it in some way, using a lifting-out technique.

For creating a mottled or broken-colour textural effect, I use a piece of kitchen paper, tissue paper or cloth, and lightly dab or press it into the half-dry colour. I might use a similar technique to lighten or soften a colour effect – by pressing down a piece of tissue paper on to an area and then peeling it off. Or, for a line or detail, I sometimes draw into the wet paint, using a piece of tissue paper held between my fingernail and the paper.

Also, depending on the type of paper being used and the colours involved, you can apply this technique to parts of a watercolour that have dried, for example if you want to reduce the intensity of a colour or introduce a highlight. To lift out a patch of colour, first wet the area with a medium soft-haired brush and some clean water, working the water slightly into the surface of the paper, but taking care not to damage it. Then use some tissue paper or a dry brush to soak up the disrupted colour. Blot the area further with tissue paper, and when it is completely dry you can repaint it as required.

Note that while it is possible to remove much of the paint and so create a much lighter area in this way, it is seldom possible to restore the white surface of the paper. This is because many colours have a significant staining quality and thus a certain amount of colour is absorbed into the fibres of the paper (see page 56).

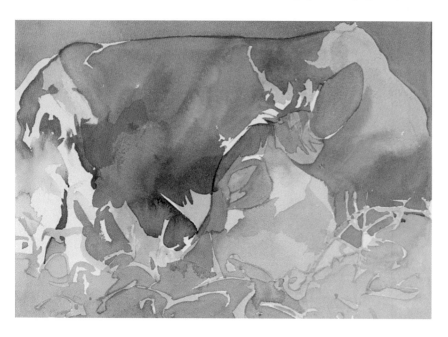

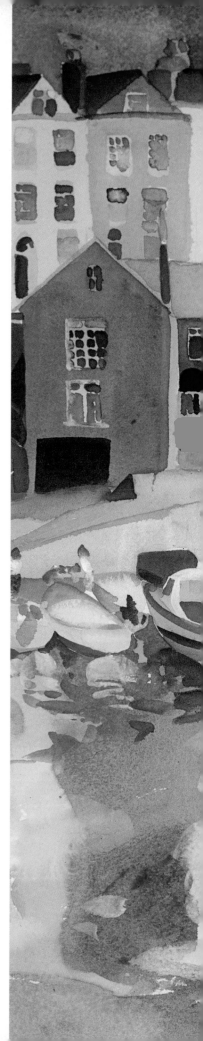

Sleeping
watercolour
18 x 25.5 cm (7 x 10 in)
There are occasions when single washes of colour are sufficient to express an idea, particularly when working on location and when time is limited.

Tenby
watercolour
40.5 x 48 cm (16 x 19 in)
The advantage with this type of subject matter is that I can work on a small area at a time and gradually develop the painting in this way.

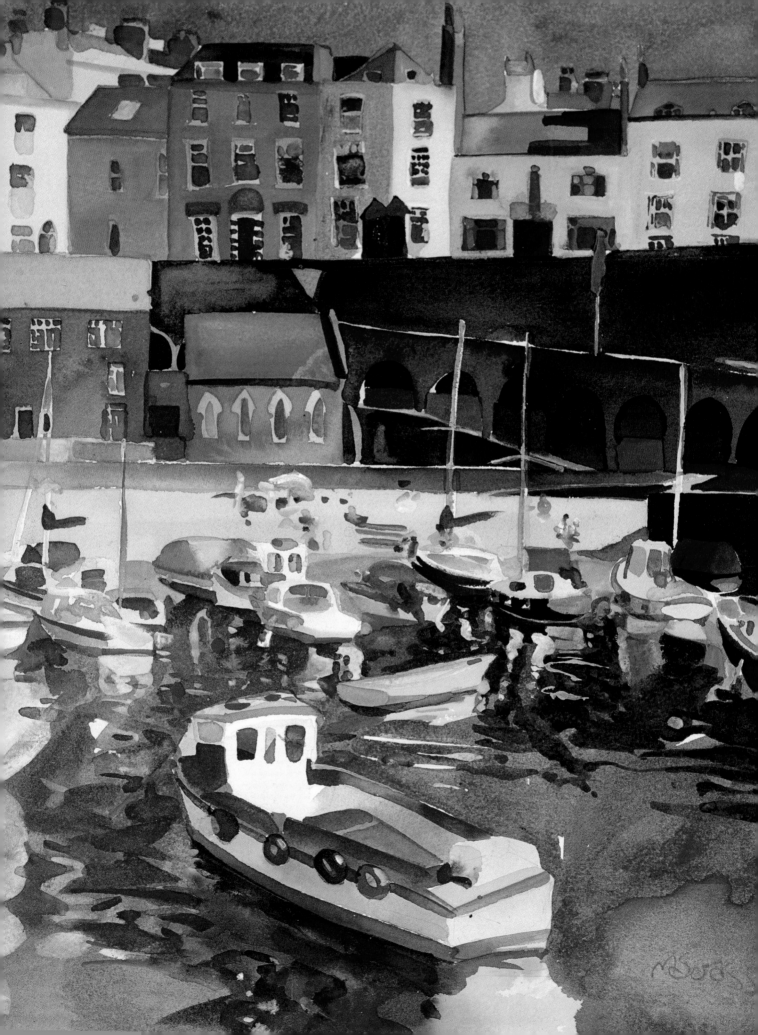

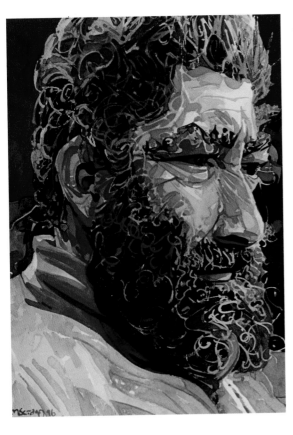

Other Techniques

Lifting out, using masking fluid, and wet-on-dry are all techniques that allow a fair degree of control. And this is what I like: it sounds like a contradiction, but I try to work with controlled spontaneity! Even in my abstract paintings, nothing is left completely to chance. I am not the sort of watercolourist who hopes for 'happy accidents' or exciting back-runs and other chance effects that might contribute to the impact of the work. Instead, I prefer to use techniques that enable me to develop an idea in the way I wish, but at the same time using that control to ensure that the paintings are lively, original and freely expressed.

Essentially, although a painting will, I hope, look spontaneous, it is actually the result of considered ideas and processes based on experience, rather than pure intuitive expression. This applies just as much to what look to be quite random textural effects as it does to my principal working method of using sequential colour washes. For example, I occasionally use a flicking or spattering technique to suggest a certain texture and in the past I have also used bleach, salt and wax-resist techniques. But these have always been incorporated with forethought and due regard for their impact within the general concept for the work.

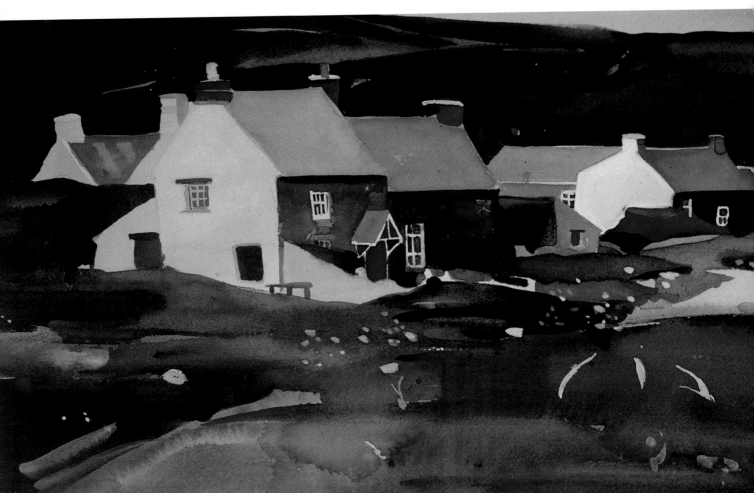

Denis the Gardener (left)
watercolour
51 x 35.5 cm (20 x 14 in)
By combining different brushwork techniques, and perhaps using masking fluid in some areas, watercolour will give a surprising variety of textural effects.

Pembroke Cottages
(below left)
watercolour
30.5 x 42 cm (12 x 16½ in)
Drawing and design are always more important qualities than detail, I think.

Women (right)
pencil, pastel and watercolour
23 x 28 cm (9 x 11 in)
By concentrating on bold shapes and simple blocks of colour, you can quickly capture the essence of a scene like this.

Watercolour and Other Media

While I attach much importance to the purity and freshness that can be achieved with watercolour when used as a medium in its own right, as in *Tenby* (page 29), I also occasionally like to experiment with paintings in which watercolour is combined with other media. Usually the reason for working in this way is that other media are better suited to interpreting different textural qualities. Equally, there is an advantage in the fact that a mixed-media approach creates contrasts in colour, technique and other aspects that will add to the interest and impact of a work.

Pastels respond particularly well over watercolour washes and, as you can see in *Women* (above), you can use it to model forms and introduce more variety to the surface quality of a painting. Also, I sometimes work with a combination of pen and ink and watercolour or, as in *Blue Nude* (page 32), by using all three media: pastel, pen and ink, and watercolour. However, I am always very careful about the media I use. There has to be a reason for choosing them. It should never be just a matter of using mixed media for the sake of it. For this type of painting to work successfully, there must be a sensitive visual and technical affinity between the different media used.

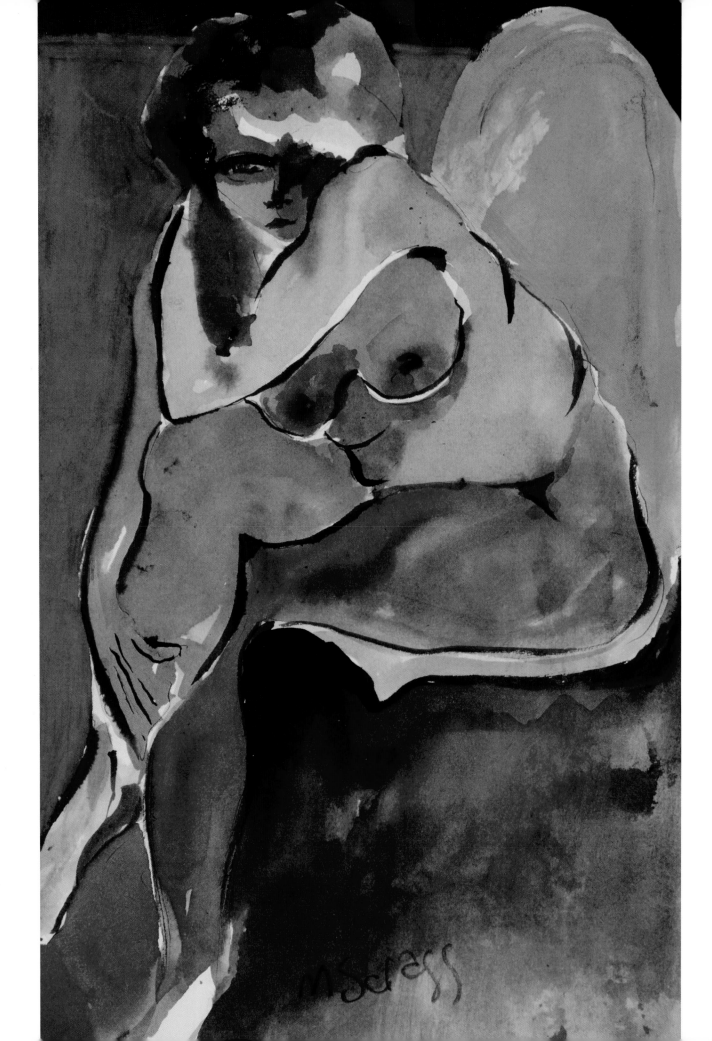

Interesting Combinations

Spanish Sketch (above)
watercolour and collage
20.5 x 30.5 cm (8 x 12 in)
I sometimes start with a small
watercolour sketch like this,
which I subsequently use as the
reference for a much larger
work, either in watercolour or
another medium. In this case
the larger painting was in oils.

For me, the most exciting mixed-media technique is to combine watercolour with collage. I enjoy the scope that this allows for creating contrasts between areas of texture (the torn or cut collaged shapes) and the translucency of the colour washes, with the luminosity of the white paper showing through. Recently I have taken this process further by working with acrylic paints and inks, again mostly applied as washes or glazes and combined with collaged shapes which, for these paintings, I have cut or torn from paper off-cuts or rejected or abandoned watercolour paintings.

Pink Jazz (page 34) is an example of this technique. I worked on a large sheet of watercolour paper, making various marks, splashes of colour, masked-out areas and other blocks of colour as a starting point, and then painting the remaining areas bright pink. Next, I added the collaged shapes. These were cut from painted papers and offcuts selected from the various papers that I have collected over the years and which are stored in a plan chest in my studio. I chose shapes that I felt would work well together to form a successful design, gluing these in place and, in some areas, superimposing and layering them, in a technique rather like the one I use for building up effects with colour washes.

Although I was quite happy with the relationship of shapes, colours and textures at this stage, I felt that the design could be even more interesting if I were to develop some areas further by cutting through the layers of collage to reveal contrasting shapes and effects beneath. I used a sharp scalpel to do this, carefully cutting out each shape and lifting it away from the surface. Eventually, I decided that the painting was beginning to look too busy, so then I returned to the painting process, applying some simple blocks of colour to quieten down the design and create a more integrated result.

There are other ideas for using collage and associated techniques that I am hoping to develop more in the future. For example, I would like to try some designs that incorporate stitching and textural effects created with thread. Also, I am experimenting with abstract

Blue Nude (left)
pen and ink, watercolour
and pastel
18 x 10 cm (7 x 4 in)
Watercolour combines well
with pen and ink and other
media for quick studies, as
in this example.

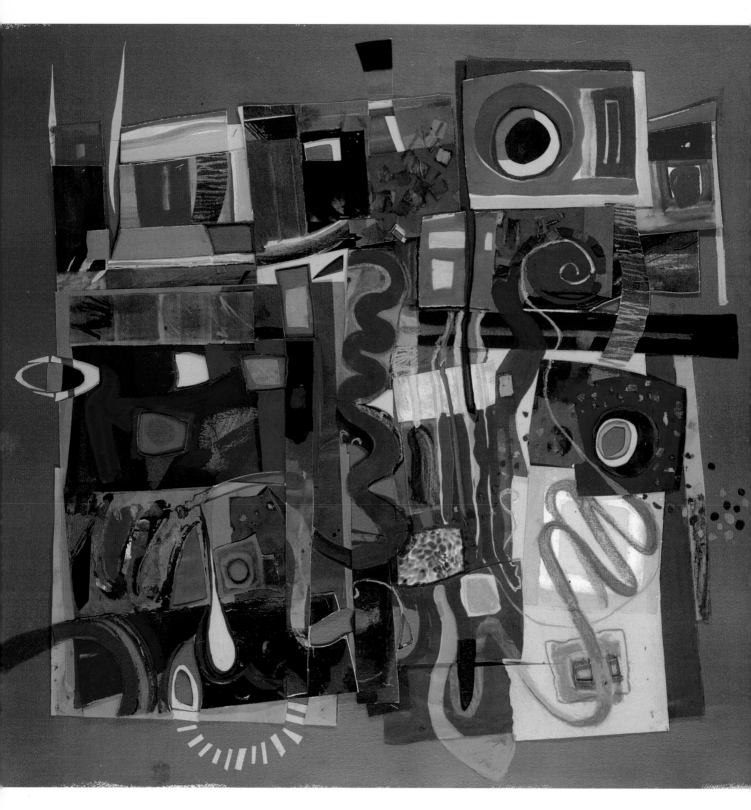

Pink Jazz
watercolour and collage
122 x 127 cm (48 x 50 in)
In my abstract paintings I often combine
watercolour with collage, using shapes
cut from painted papers or some of the
various handmade and other papers that
I have collected over the years.

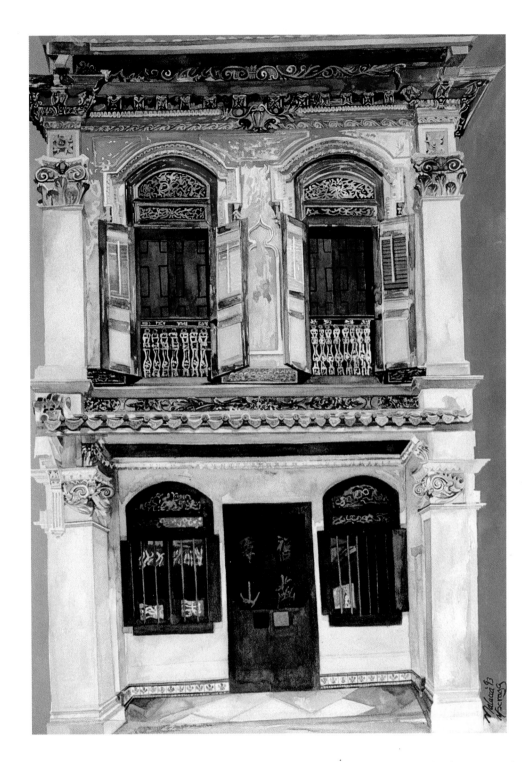

Malacca
watercolour
81 x 61 cm (32 x 24 in)
Essentially, success with this
sort of study depends on
careful observation and sound
draughtsmanship.

acrylic paintings made on MDF (medium-density fibreboard), into which I have carved different shapes and patterns. Then, when the painting is completed, I pour coloured resin into the carved areas, which adds a shimmering, glass-like quality to the work.

Sometimes I like to rework a watercolour on a much larger scale and in a different medium, or perhaps start with a watercolour as the reference for another painting. This was the case with *Spanish Sketch* (page 33), which, as you can see, is quite a small collage and watercolour painting. Working from the sketch, I made a large 152 x 183 cm (60 x 72 in) oil painting, and this inevitably involved a huge technical challenge in interpreting the various textures, the sharpness of colour and the spontaneity of approach. But it was a challenge that I greatly enjoyed!

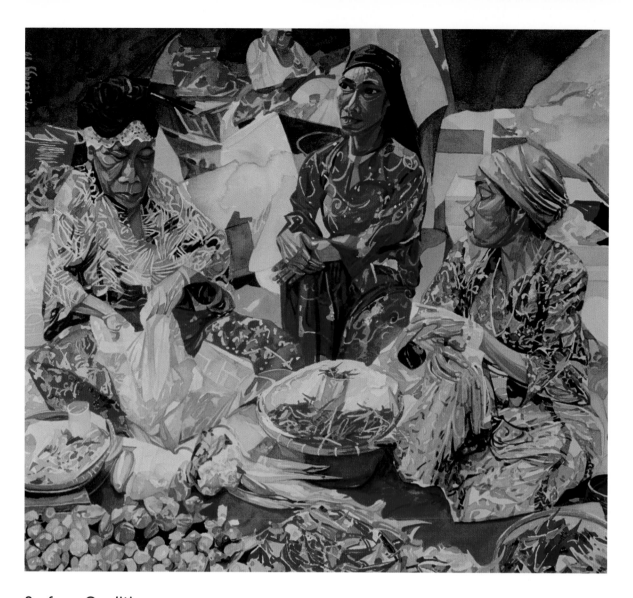

Surface Qualities

Obviously, the surface quality of a painting will be greatly influenced by the particular techniques used to apply the various colours, as discussed on pages 22 to 30. But equally, there are more fundamental factors that play a part, such as the choice of brushes, the type of paper, and the viscosity or consistency of the paint itself. For example, if you work with a flat, stiff-haired brush, with paint of a slightly thicker consistency than usual, you can exploit different brushmark effects by dragging, stippling or manipulating the brush in different ways – especially when this approach is used on heavy-quality textured paper.

In fact, on a Not paper (cold-pressed paper), and certainly on a Rough paper, even when watercolour is applied as a flat wash, a degree of texture will be implied from the surface beneath. Another point to bear in mind is that some colours have an inherent textural quality – a tendency for the pigment particles to separate as the colour dries, so creating a grainy effect, known as granulation. Colours that have this characteristic include cerulean blue, burnt umber, raw umber, raw sienna and yellow ochre.

Rather like the detail in a subject, the different textures can seem very interesting and attractive, and this, without due care, can result in too much emphasis being placed on them. In every painting it is a matter of balancing the various elements that you feel are important, and doing just enough to express the mood and impact you have in mind. However, should a painting start to look fussy and laboured, there are various ways of improving it.

Chillies
watercolour
61 x 63.5 cm (24 x 25 in)
In a studio painting such as this, there is more time to work on detail and texture, yet always keeping these qualities within bounds so that the painting does not start to look fussy and laboured.

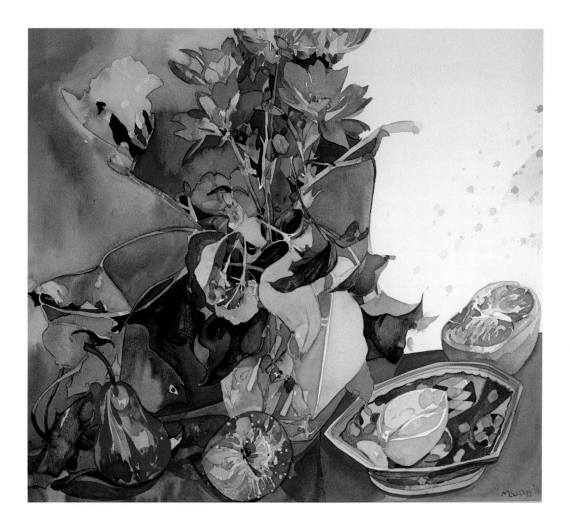

Flora and Fruit
watercolour
63.5 x 71 cm (25 x 28 in)
Very occasionally, something accidental happens that can prove an advantage to the painting. Some drips of paint accidentally fell on this painting and I decided they were just what was necessary to finish the work!

The main difficulty, when making changes to a watercolour painting, is ensuring that they are not too noticeable against the rest of the work. In fact, certainly with major alterations, it is seldom possible to lift out colour or repaint an area without it showing to some extent. Therefore, the best policy is to avoid making changes unless they are absolutely necessary. In watercolour, perhaps more so than in any other medium, it is essential to work with an awareness of the consequences of the different techniques you are using, so that as far as possible you can create the right effect at the first attempt. This is the best way to keep the painting lively and the colours fresh.

When something does go wrong, you may be able to put it right by using the lifting-out technique described on page 28. Do this gradually, wetting the area and then dabbing it with some kitchen paper or tissue paper to soak up the colour. If necessary, contain the area that you want to work on by painting masking fluid around the edges. Having removed the 'mistake', and when the paper is dry, you can repaint the area as required.

If more drastic measures are called for, my advice is to take a big brush and block out the entire problem area with flat, opaque colour. For example, you may want to simplify some areas of a painting that are beginning to look too detailed and busy. Again, ensure that the surface is dry before you add any modifications to the newly applied colour.

In contrast, there are times when an accident or mistake can be exploited and used as a positive element in a painting, so hold back from taking remedial action until you have assessed the situation. This happened with *Flora and Fruit* (above). Some drips of paint accidentally fell on the painting and I decided that these could be left and in fact that the essence of the painting would be lost if any further colours were added. So, in this instance, it was a fortuitous accidental texture that brought the painting to a conclusion!

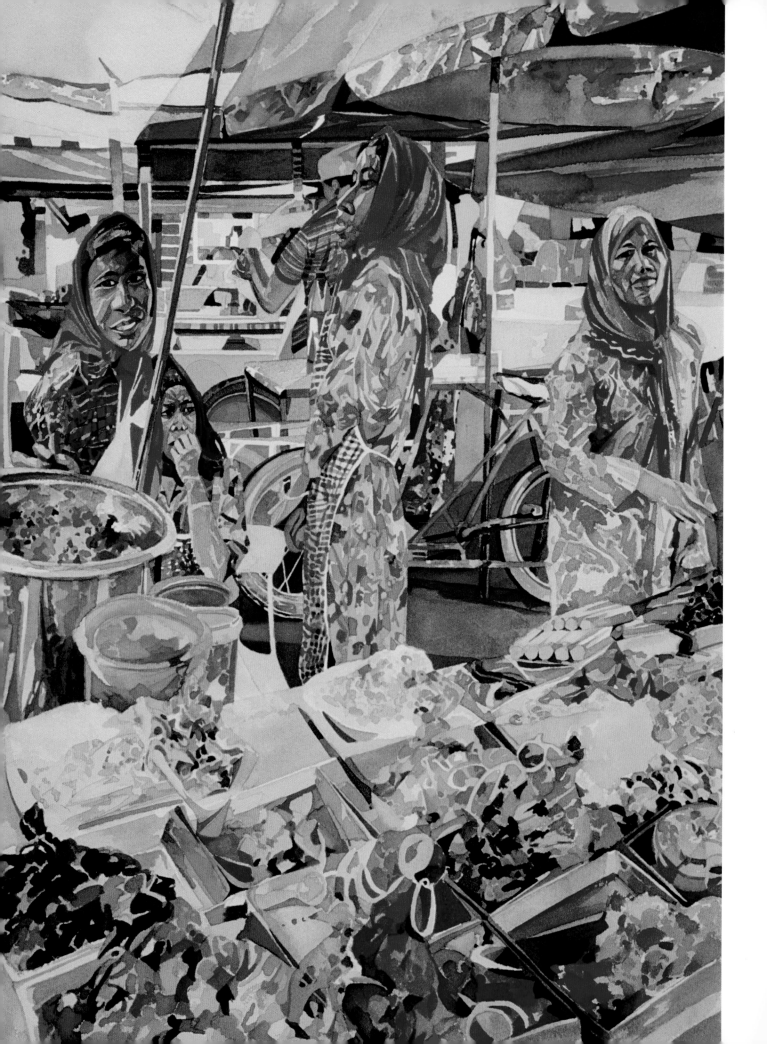

Bold Colour

I have always been interested in colour as the principal means of expressing my thoughts and feelings, irrespective of whether the subject matter is obviously colourful, such as a still life with flowers, or I have chosen something in which colour is inherently more subtle. For me, it is colour that adds the energy and excitement to a painting and usually, as well as being the quality that initially attracts me to the subject matter, it is also the aspect that I want to concentrate on and use to maximum effect.

But my love of colour is not sufficient in itself to create successful paintings, of course. The impact of a painting cannot rely on the use of colour alone, however well considered the choice, placing and interaction of the various colours. In any painting, and perhaps especially in those in which colour is the key influential element, it must also work in terms of the design. This is because the way that we view and understand a painting is inevitably determined in part

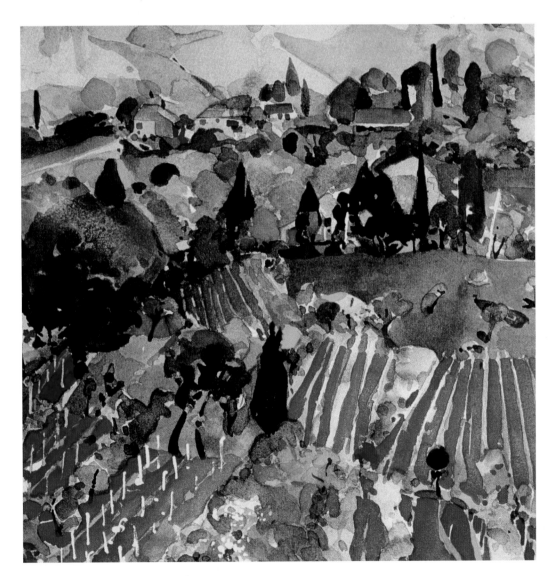

Blue Rice
watercolour
63.5 x 38 cm (25 x 15 in)

Tuscan Vineyard
watercolour
20.5 x 20.5 cm (8 x 8 in)
A good way to create a sense of unity in a painting is to repeat certain colours at intervals throughout the composition.

by the balance, contrasts, patterns and rhythms of the different colours used – the various shapes and areas of colour and how these create a dynamic and interesting design.

In addition to the relationship between colour and design, and the need to start with a sound structure for a painting, success with colour depends on a good understanding of tone – the relative light/dark strength of a colour. Therefore, when selecting a colour to use, you also need to consider its tonal value – how light or dark it should be within the overall context of the painting.

When you first start painting, judging the variation of tone can be quite difficult. If you are working directly from the subject matter, one useful technique to help you estimate tones is to look at the scene or objects before you through half-closed eyes. This will enhance your perception of tone, rather than only having an awareness of colour, and give you a better sense of the general tonal distribution.

Tone is important in several ways: it helps convey the illusion of three-dimensional form, together with space and depth in a painting; it assists in the expression of a certain mood, for example subtle tones suggest a calm feeling whereas strong tonal contrasts create a sense of drama or mystery; and, in more general terms, variations of tone will add to the overall impact of a work.

When a watercolour is unsuccessful, it is usually because the tonal values haven't been considered carefully enough. A painting can display accomplishment in technique, yet be rather unexciting and ineffectual because the tonal contrast is limited and underplayed. My advice is to exaggerate the tonal contrast. As well as a large variation of mid-tones, I normally include some very strong, rich tones and intense highlights. This approach, in conjunction with the actual choice of colours, generates greater vitality and interest in each painting. See *Man and His Dog* (opposite).

Colour and Mood

Although it is generally a colour or a particular relationship between colours that inspires me to paint something, I never feel compelled to keep to the colours that I observe. Instead, I prefer to make a more personal response, to reflect what I sense as the distinctive mood and appeal of the subject matter. Naturally, this involves a certain amount of selection and exaggeration as far as use of colour is concerned.

Of course, whatever your intentions in a painting – whether you wish to work in a totally representational way or adopt a much more subjective approach – colour is always the key factor in helping to communicate the elements and characteristics that you regard as important in the subject. Moreover, in order to express qualities such as mood and atmosphere convincingly, you will probably find that some adjustment or emphasis to the colour scheme is necessary, even if your aim is to make a truthful depiction of the subject.

In time, expressing mood through colour becomes an instinctive process, although it may well remain influenced by various aspects of colour theory, such as using complementary, analogous, limited or harmonious colours. Throughout the painting process you have to be aware of the combinations of colours you are using and the overall feeling these are creating.

Man and His Dog
watercolour
35.5 x 15 cm (14 x 6 in)
Here again it is the contrasts of tone, from intense highlights to rich darks, that generate vitality and interest in the painting.

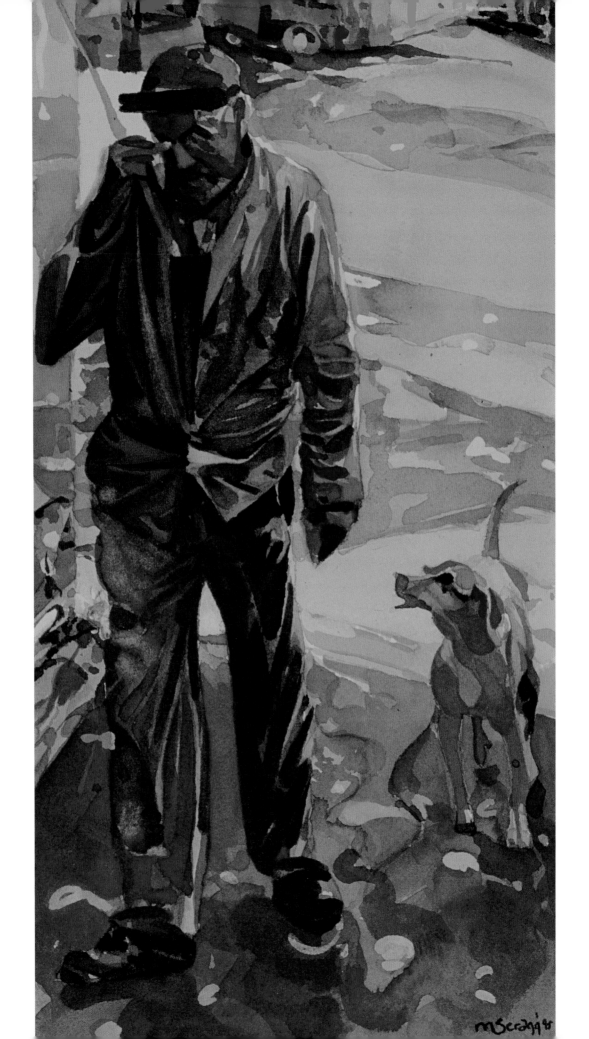

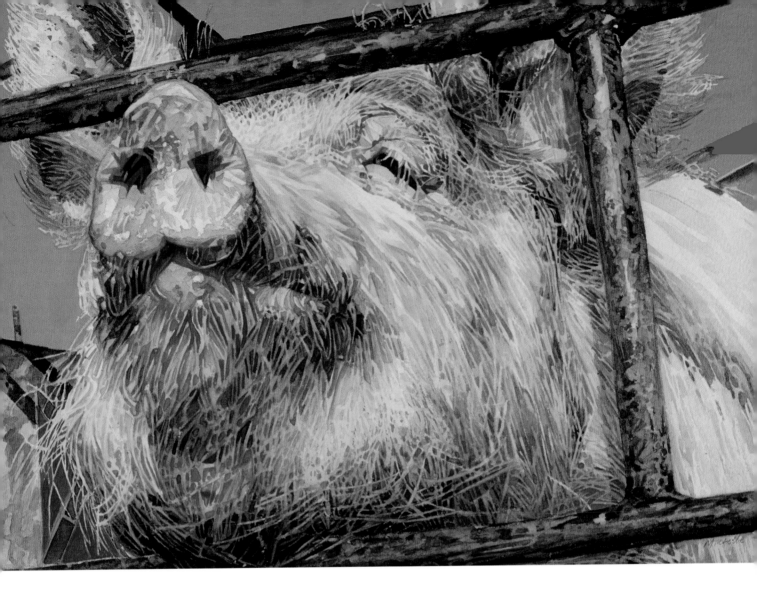

Descriptive Colour

Colour can be used in a descriptive way to support an objective approach and help convey a true likeness of the subject matter, or you can work more freely and expressively, emphasizing selected colours and colour interactions to evoke a certain effect or response.

Most artists begin their career by painting from observation and consequently their aim is to reproduce the colours that are there in the subject matter before them. Indeed, some artists prefer to keep to this method of working: they enjoy the challenge of depicting things exactly as they are, without alteration or exaggeration. Certainly it is an approach that has many advantages when learning about the qualities and characteristics of different colours and how to assess and mix specific colours.

The best way to gain confidence with colour is, of course, to use it and experiment with it. You can do this in a formal way, for example by making a colour wheel or colour charts to identify different colours and colour mixes. Or you can simply learn from your successes and mistakes as you test out new colour combinations and mixing techniques in your paintings.

Naturally, it takes a good deal of practical experience before you can mix a colour from those in your paintbox or palette to match a particular colour in the subject matter before you. Moreover, the process is further complicated by the fact that each colour is influenced by those around it. Therefore you may find that, although you have mixed a colour quite accurately, when you place it in context in a painting it looks slightly stronger or weaker in

Portrait of a Pig
watercolour
43 x 81 cm (17 x 32 in)
This is what I would term 'descriptive colour'. Sometimes there is no need to enhance the colours found in the subject matter, other than perhaps to strengthen them – they are very effective as they are.

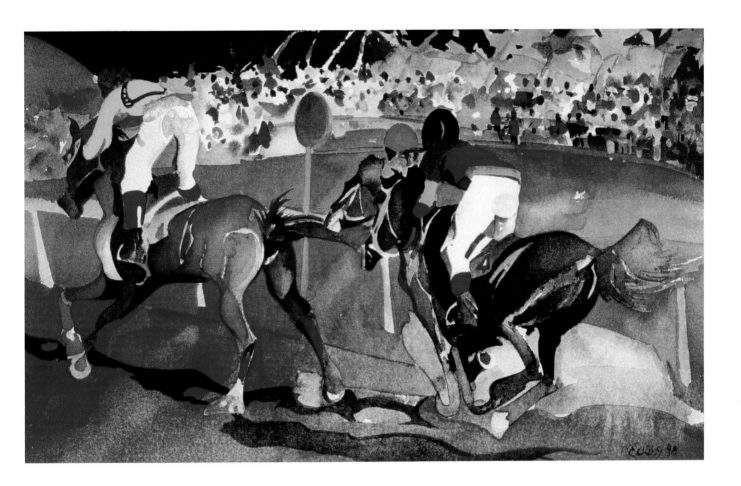

**Horse Race,
Indian Castle, Nevis**
watercolour
11 x 15 cm (4½ x 6 in)
I enjoy making little studies
like this on location,
particularly if I am not
disturbed!

tone, or cooler or warmer in colour key, than you had anticipated. In this case, the colour will need adjusting to suit its context.

There are artists who have a natural flair for judging colours and knowing which combination is required to mix a colour that will match the one in a particular part of the subject matter. However, if this is something you find difficult, the thing to do is check each colour match on a trial-and-error basis. First, try out the colour on a piece of scrap paper, and then hold up the test piece to the relevant part of the subject matter to check whether the colour is acceptable. If it is wrong you can adjust the colour mix, although keep in mind the importance of using fresh, transparent colours. Start again if you feel the colour mix is becoming 'muddy'.

Essentially it was by experimenting in this way that I added to my knowledge of colour. I used to do a lot of representational drawing and painting, but now there are few paintings in which I would define the colour as descriptive. The nearest I get to this approach is in paintings such as *Portrait of a Pig* (opposite), although you will notice that even here I have worked with a heightened sense of colour. Mostly I like to interpret colour and I will choose colours that work well together, as in *Finishing Post, Indian Castle, Nevis* (page 44), rather than relying exclusively on the true colours.

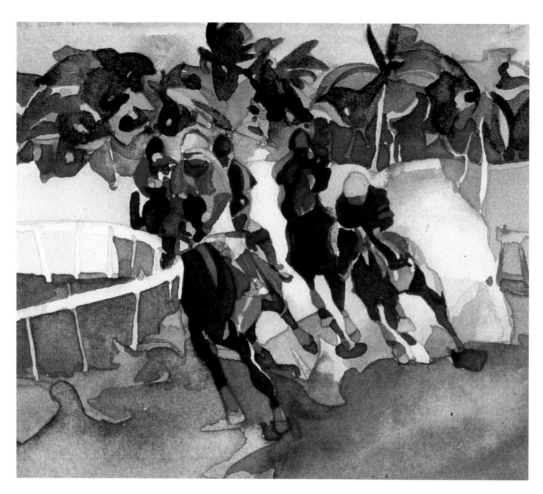

Expressive Colour

Colour can be the most powerful quality in expressing your feelings about a subject. In making an instinctive response to those aspects of the subject that most impress you, there is the freedom to use whatever colours will best convey the particular effect and impact you have in mind. Here again, to create a coherent and successful design, the specific choice, distribution and interaction of colours must be carefully considered.

The strongest sensations come from sharp contrasts of colour – the use of counterchange (light against dark, or vice versa) or complementary colours, for example – and colour associations. Red, for instance, is generally viewed as an active, aggressive or passionate colour, whereas green and blue are the colours of nature and are therefore calm, harmonious colours. But colour is a very subjective quality and the perception of colours and their interaction operates at many different levels of physical and emotional response. Not everyone will see the same attributes in a given colour. Essentially, it is the context in which the colour is used that creates a certain impact, and this is the aspect to exploit when working in a more expressive manner.

Incidentally, it is worth emphasizing that the distinction between descriptive and expressive colour is not always that obvious. For example, even when you are painting in a descriptive manner, there is often a need to exaggerate certain tones or colours to enliven an area or help the viewer read and understand it correctly. In many of my paintings I keep to a limited palette of colours, which I think helps in expressing the mood I want and also in exploiting colour contrast and harmony.

Shalese (opposite) is a good example of this approach. I painted this quiet, shy girl when I visited the Caribbean. Although I had expected to paint mostly landscapes, surprisingly it

Finishing Post,
Indian Castle, Nevis (above)
watercolour
23 x 35.5 cm (9 x 14 in)
Generally, my approach to colour is subjective and I choose colours that work well together and create a strong impact.

Shalese (right)
watercolour
56 x 35.5 cm (22 x 14 in)
Usually, the most effective way to convey a particular mood for a painting is to work from a limited palette of colours.

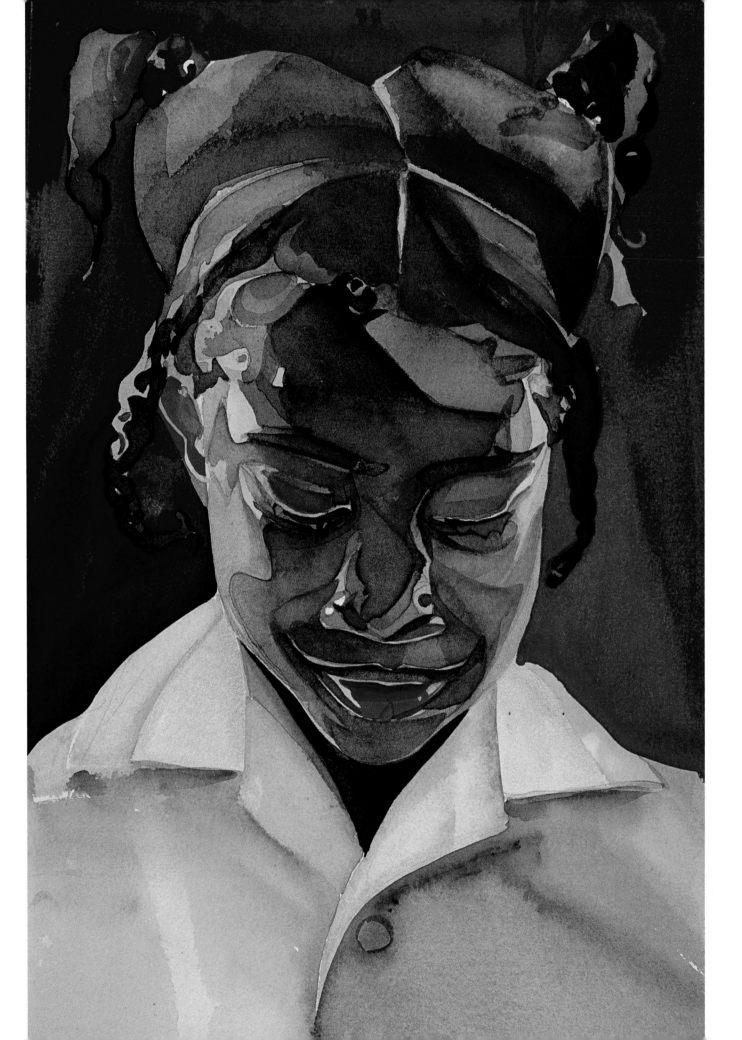

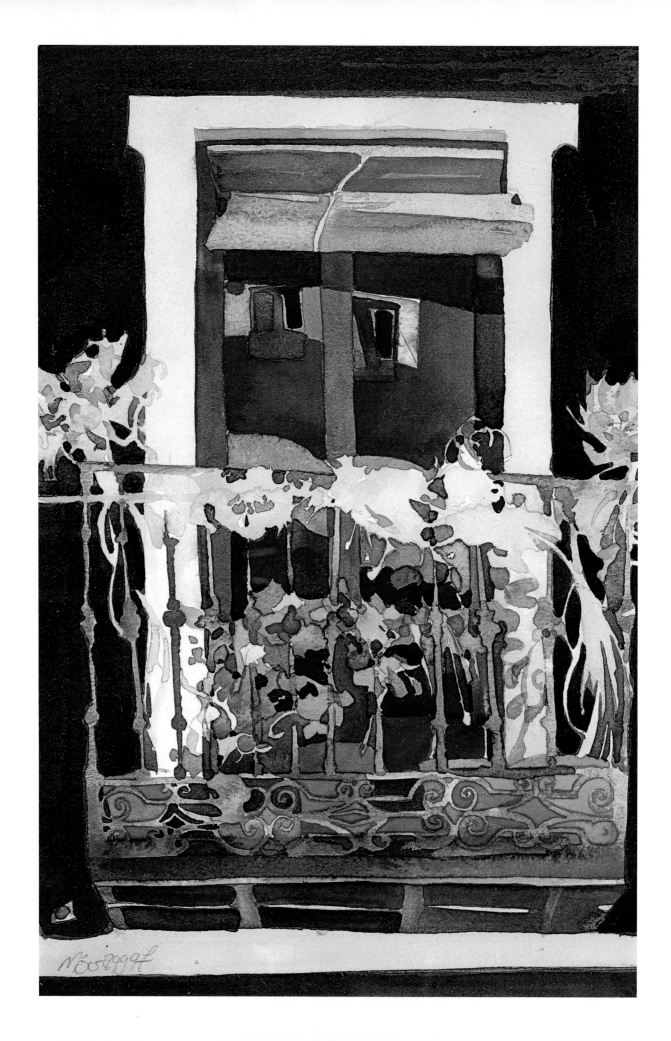

The Balcony (left)
watercolour
30.5 x 18 cm (12 x 7 in)
Simple blocks of colour can
be very effective and convey a
surprising amount of
information.

Red Floral (right)
watercolour
66 x 28 cm (26 x 11 in)
As here, sometimes I restrict
the colour palette even further
and virtually work within a
single colour range.

was the people who interested me the most. Impressed by the colour of the girl's uniform and the bobbles in her hair, I decided to work with a very limited palette of pinks and blues to create a soft, moody quality in the painting. In fact, adopting my standard technique of using white plates as palettes, I worked from light red, cerulean blue and cobalt blue on one palette, with the necessary colours for the face, the browns and oranges, on another palette. In this way I could keep the two sets of colours fresh and untainted.

In retrospect, this was an important painting for me, because I felt I had achieved the particular qualities I had been working towards for some time. It was how I wanted a watercolour to look: it wasn't overworked; using a limited palette and by introducing some reflected colour in the face and other areas, the overall colour effect was strong yet harmonious; and I had successfully expressed the mood that I had intended for the painting.

Occasionally, in order to ensure that a painting works effectively, I restrict the colour even further, and as in *Red Floral* (above), I might decide to work mainly within a single colour range. In fact, this painting has an interesting history. Originally the colour was more varied, and although I felt it was handled well, as was the basic drawing and composition of the work, somehow the painting lacked depth and therefore impact. It would go off to exhibitions and always return!

Therefore I decided on a course of action that I rarely take, which was to rework parts of the painting. I considered that if I were to limit the colour range and give more credence to the tones, this would produce a much stronger image as well as one that was more in keeping with my usual style. So, having removed the watercolour from its frame, I stretched it (by wetting the back of the painting and taping it to a board) as a precaution against the surface distorting while being repainted. Then I isolated the areas that I wanted to modify by defining their boundaries with masking fluid.

I decided to work predominantly with reds, which I felt would enhance the sense of depth and add to the overall impact of the painting. This also gave the painting more unity. In fact, ultimately about 80 per cent of the image was painted in some kind of red. I had five plates (palettes) and mixed a variety of interesting reds to work from. Surprisingly, although enjoyable to use, red is quite a difficult colour to make exciting. An entire painting based on reds can look really flat and uninteresting. As always, the secret lies in achieving the right contrast and balance of tonal values.

Neon Lights
watercolour and acrylic
51 x 71 cm (20 x 28 in)
Especially in my abstract
paintings, I like to experiment with
new colour harmonies and, by
combining watercolour with acrylic
paint, exploit different qualities of
transparency and opaqueness.

Colour in Action

Naturally, because colour is the principal quality in my paintings with which I create mood and impact, it is essential that I make the right choice of colours. While every colour works individually in conveying information about the subject matter, it also contributes positively to the overall visual statement that I want to make. The way that artists work with colour is often largely instinctive. However, this approach is usually born from the study of – or at least the experience and experimentation with – such aspects as colour key and colour interactions, which are now discussed.

Moreover, in my view the need for experimentation and modification within the painting process is a continuing one. This particularly applies to the use of colour. There can be advantages in keeping to a certain range of colours, but if this always results in the same, well-proven colour mixes reappearing in every painting, then their impact is greatly reduced.

As with *Neon Lights* (opposite), I think it is a good idea to introduce a new challenge in each painting – perhaps, as here, by exploring the potential of selected colour harmonies and contrasts that you haven't tried before. Also, you will see that in this painting I have combined watercolour with acrylic paint for the final stages. This allowed me to contrast areas of transparent colour with flat, opaque shapes, painted in acrylic, to produce a much stronger colour statement.

Colour Key

The overall impression of colour and tonal values in a painting is known as the colour key. Assessing the colour key is one of the most important considerations when viewing the subject matter and deciding on the approach to colour that you should take. The term 'key' refers to the general characteristics of the colour, whether it is warm, cool, neutral, bright or whatever. Essentially, a painting in which mainly bright colours are used is said to be high key, whereas one that relies on dark colours and tones is said to be low key.

As I have mentioned, I like the challenge of setting aside my normal choice of colours and introducing a completely different set. To help with inspiration for new colour combinations, I collect ideas from different magazines – colours in advertisements or photo shoots that have attracted my interest, for example. I cut these out and pin them to my studio wall for reference. Then, if I am not sure how to finish a painting, I will look at the colour samples and check whether there is a colour, or colours, that interest me and seem suitable.

Directly related to this, of course, is the need to judge the tone of each colour accurately. Tone is vitally important in my paintings: it adds the contrast and drama. I always start with the lightest tones, working with subtle washes of colour. For me, these are the basic guidelines for the painting. They are my working marks. Once I am content that they are in the right place I preserve them – usually by protecting them with masking fluid – and then I can assess the remaining tones in relation to them, building up the necessary strength of tone in layers of colour according to what I sense is required for any given area.

Blue Thistle
watercolour
25.5 x 15 cm (10 x 6 in)
The overall impression of colour and tonal values in a painting is known as the colour key. Here, I decided to work with a range of blues, creating a harmonious, low-key effect.

Colour Relationships

Although my approach to using colour is essentially intuitive and expressive, inevitably my thinking is influenced by accepted ways for enhancing colour impact. However, I never consciously apply colour theory: I like to be free to respond to whatever is happening in the paintings and, if necessary, adapt and rework colours. If colour theory is allowed to dominate, paintings can very easily look contrived, and so lose their vigour and appeal.

Nevertheless, as part of gaining some knowledge and understanding of colour, there is value in covering at least the fundamentals of colour theory, as this in turn provides a useful basis to build on. For example, you could make some colour charts that you initially refer to, just to remind you of what happens when you mix certain colours together or place them next to each other. Similarly, a 'colour wheel' is always a helpful form of reference when considering different colour theories. Again, it needn't be allowed to completely govern your thinking, but instead might suggest some useful ideas or starting points for you to develop in your own way.

To make a colour wheel, start by drawing a circle 15 cm (6 in) in diameter on a thick sheet of paper, and divide this into 12 equal segments. Use watercolour paint of a fairly thick consistency, so that when the colours are applied they are solid and opaque. Start with the three primary colours (using perhaps cadmium red, cadmium yellow and ultramarine) and position them at intervals of one-third around the wheel. Next, add the three secondary colours (orange, purple and green – each of which is a mixture of two primaries): these are placed halfway between the appropriate primary colours. The remaining spaces are filled with a

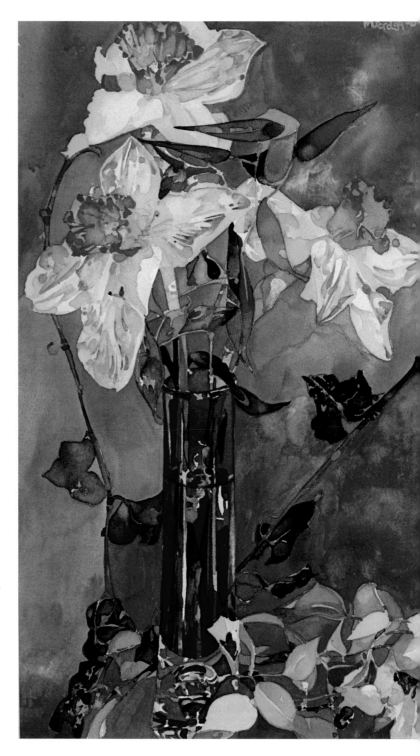

Daffodils
watercolour
43 x 28 cm (17 x 11 in)
In every painting I try to contrast some passages that are busy and interesting with other areas that are quiet and restful – the background in this painting, for example.

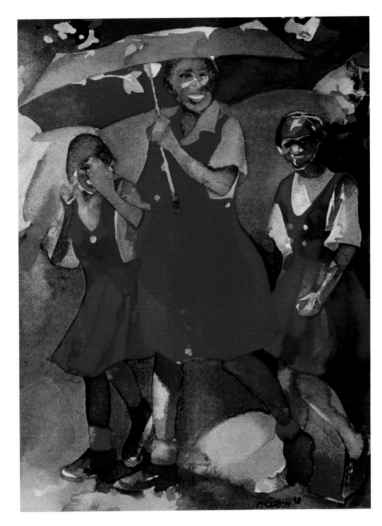

School Girls, Nevis
watercolour
38 x 23 cm (15 x 9 in)
The colours in this subject are much warmer and stronger, giving a high-key effect.

mixture of the adjacent primary and secondary colour – for example, between yellow and green use a yellow/green colour, and between yellow and orange, a yellow/orange colour.

From the colour wheel you can easily identify analogous or harmonious colours (those next to each other, or groups of colours in the same section of the colour wheel), or alternatively contrasting or complementary colours (those opposite each other). There are many helpful books and courses available, should you wish to study any aspect of colour theory in more depth. You will find details of these in art magazines.

But, as I have said, don't be afraid to experiment and use colour in an adventurous and individual way. In my view, you can put any colour next to any other colour, because it is not just the colours themselves that matter. Equally important factors are the amount of colour – the shape and area it covers – and its tonal value. Also, you have to consider the context of the colour, its relevance and impact within the overall composition.

Especially with abstract paintings, I often find that, having started with one idea, it can very soon develop into something quite different. The process is a journey, and the outcome is always influenced by things that happen on the way. For example, the coincidental placing of two colours might be so dramatic and exciting that, in order to keep them and enhance their effect, I decide to alter almost everything else. All the time I am thinking about harmony, proportion, space and how each shape or colour is working in relation to the whole. As in *Daffodils* (opposite), in every painting there must be areas that are quiet and areas that are much busier and more interesting. Sometimes a colour will need softening and pushing back, while other colours might need enhancing and bringing forward. The painting process involves constant decision-making and adjustments to the composition and colour values.

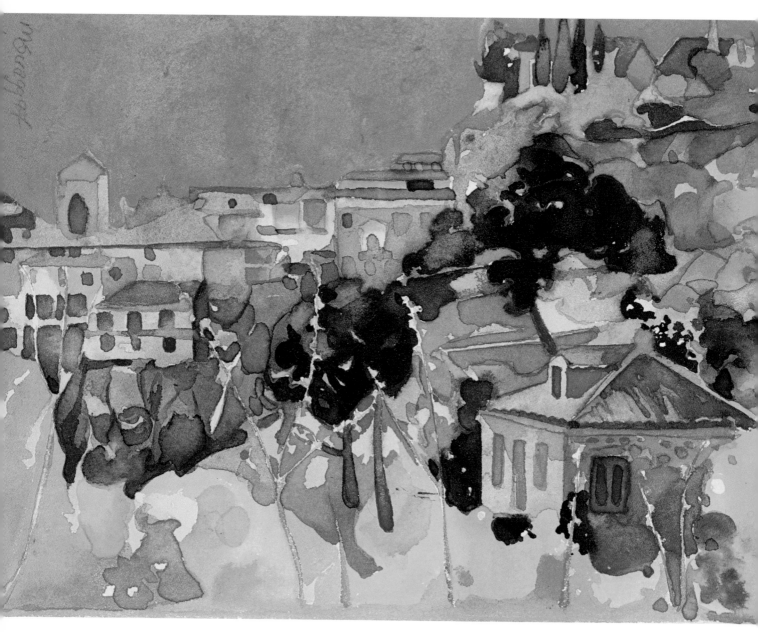

Colour and Pictorial Space

For me, when necessary, the sense of space and scale in a painting is achieved principally through a careful assessment of colour and tone, rather than relying on perspective and similar devices. Nevertheless, I will take note of particular angles and shapes where these are significant to the content and design, as with the buildings in *Late Afternoon, Heading to Cuenca* (above). Compare this to *The Toast* (opposite), in which there is nothing to infer background space except the colour itself.

In theory, warm colours, such as reds, yellows and oranges stand out and come forward, and are therefore most useful in the foreground if you are painting in a representational manner. In contrast, cool colours, which include blues and greens, tend to recede. However, it is the tone of the colour that is the most influential factor, so that in the right context a strong green, for example, could be more powerful than a weak red.

Late Afternoon, Heading to Cuenca
watercolour
18 x 25.5 cm (7 x 10 in)
While it is not necessary to worry unduly about aspects such as perspective, nevertheless it is important to carefully consider particular angles and shapes where these are a significant element of the design.

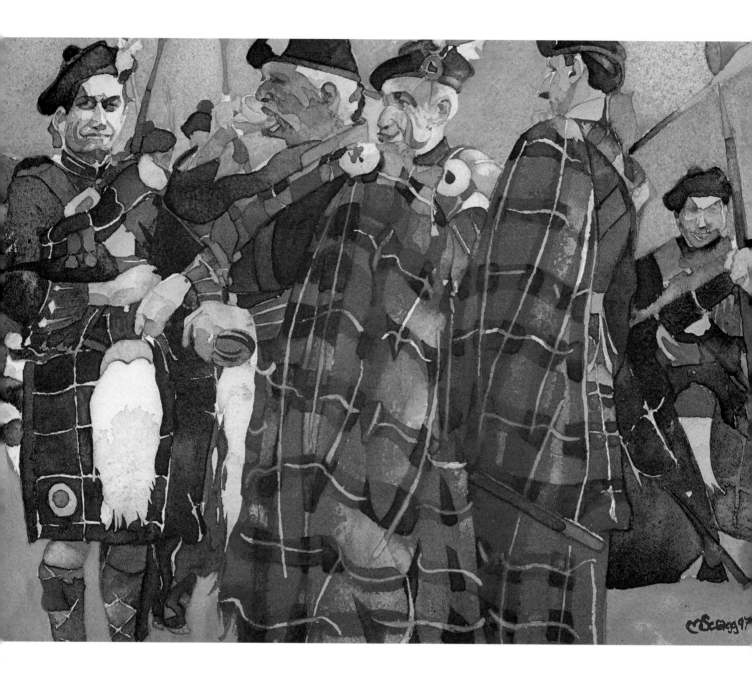

The Toast
watercolour
28 x 38 cm (11 x 15 in)
As here, mostly I infer a
sense of space through
the use of colour,
exploiting the fact that
warm, bold colours come
forward, whereas weaker,
cooler colours recede.

I paint very few landscapes now, but when I did, typically I would start with the lightest areas, perhaps a group of buildings, and then block in the darkest shapes, such as distant hills, thereby establishing the two extremes of tone to work within and fix the tonal key for the whole painting (see page 116). I might protect those areas with masking fluid, and similarly I would mask out trees and other shapes that I wanted to protect from general background washes of colour. Having also decided at the beginning which areas were going to be busy and which ones were going to be left as flat, restful areas of colour, the major part of the painting process would then involve working with sequential layers of colour to build up the desired tonal contrasts and harmonies. As necessary, I might use some reflected colour or repeated tones of colour to help unify the composition.

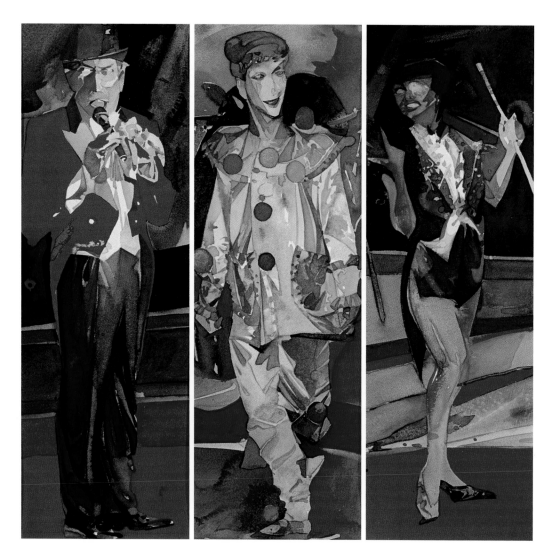

Selecting Colours

Because such a variety of colours is available – one brand lists as many as 168 different colours – there is a temptation to think that you need a huge choice to work from. In fact, generally paintings are more successful when the palette is limited to just a few colours, as this will help create better colour harmonies and contrasts. Naturally the colours you use will depend on the types of subject matter that interest you and the way you prefer to work. For instance, many landscape artists choose a limited palette consisting of mostly cool and earth colours – perhaps ultramarine, cobalt blue, lemon yellow, yellow ochre, raw umber, raw sienna, burnt umber, alizarin crimson, cadmium red and Payne's grey.

If you are new to watercolour painting, my advice is to start with a palette based on primary colours, with two reds (cadmium red and alizarin crimson), two blues (ultramarine and cobalt blue) and two yellows (cadmium yellow and yellow ochre). This will encourage you to mix colours and it will also help you achieve fresh, transparent colours. You will find that most colours can be mixed from the basic primaries. Gradually, as you gain experience and confidence in mixing and handling colour, you may wish to add a couple of earth colours to the palette (perhaps burnt sienna and raw umber) and eventually one or two other colours that you feel are essential for the subjects and effects that appeal to you.

Triptych
watercolour
33 x 45.5 cm (13 x 18 in)
I am naturally attracted to subjects that include dramatic colour and tonal values. This is one of a series of paintings that I made on the theme of the circus.

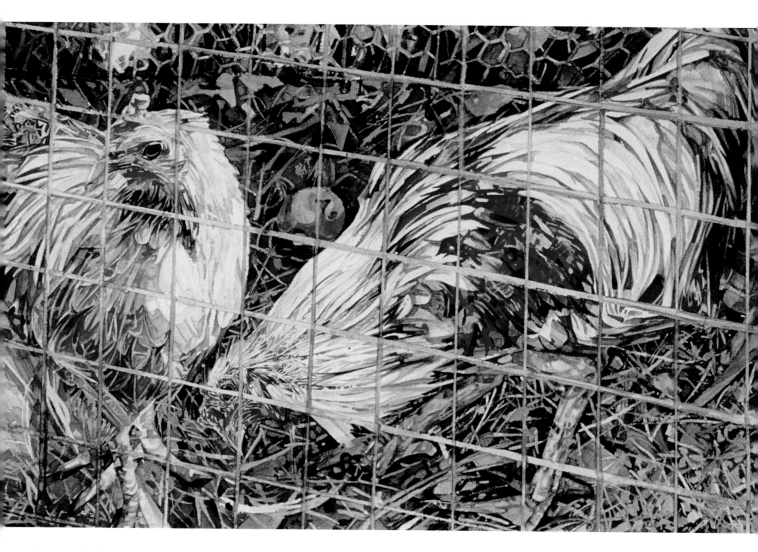

Japanese Cockerel
watercolour
40.5 x 76 cm (16 x 30 in)
I love painting cockerels: they
are such colourful and
charismatic birds.

I now use a more limited range of colours than I used to, but I try not to stick to the same colours all the time. In fact, I may introduce a different colour palette as a challenge or to add more drama and impact to a painting. It is good to step outside your 'comfort zone' now and again, I think. Particularly with abstract ideas, each painting might demand a slightly different colour palette. Normally my colours will include some of the following: cobalt violet, magenta, scarlet lake, permanent rose, cadmium red, lemon yellow, cadmium yellow, cadmium orange, phthalo turquoise, cerulean blue, ultramarine, cobalt blue, azure blue, Winsor green, emerald green, viridian, raw sienna and raw umber.

Colour Characteristics

Although watercolours share certain characteristics, there can be subtle differences between one colour and the next, and indeed from one brand to another. Watercolour paints are made from finely ground pigments dispersed evenly in a gum arabic solution or similar water-soluble gum binder. While acting as the agent to hold the pigment intact, the gum binder also allows the paint to be heavily diluted with water and so used to make weak, transparent washes of colour. Traditionally, a small amount of honey or sugar (now glycerine)

Church Door
watercolour
11 x 20.5 cm (4½ x 8 in)
This is another small study
that was made on site, so I
focused on the essence of the
scene, keeping the shapes
and colours quite simple.

is also added to the paint to improve its solubility, and some manufacturers also add ox gall or a similar wetting agent to enhance paint flow.

The exact balance of these various ingredients determines the quality and characteristics of the different brands of paint. Some brands are more moist than others, for instance, and some flow and handle more freely. Most manufacturers produce two grades of paint: artists' quality colours and students' quality colours. Artists' quality paints contain a high proportion of good-quality pigments, making them stronger and more luminous in colour.

The more you work with different colours, the more you become aware of variations in their transparency, staining power and tinting strength. You will notice that the most transparent colours allow the white reflective surface of the paper to show through and so enhance the feeling of light and atmosphere. These colours include French ultramarine, cobalt blue, scarlet lake, alizarin crimson, viridian, Hooker's green, raw sienna and gamboge. However, surprisingly, colours such as the cadmium reds and yellows, cerulean blue and raw umber are slightly opaque, which is something to bear in mind when choosing and mixing colours. When mixed with other pigments, opaque colours reduce the brilliance and luminosity of the resultant wash.

Staining pigments, as the name implies, are those that will soak into the paper fibres to such an extent that they cannot be lifted out without leaving a trace of colour. These colours include Prussian blue, sap green, Winsor red and quite a few of the cadmiums and earth colours. The tinting strength of a colour relates to its power when used for mixing a wash or in a mixture with other colours. Some pigments, for example alizarin crimson and burnt

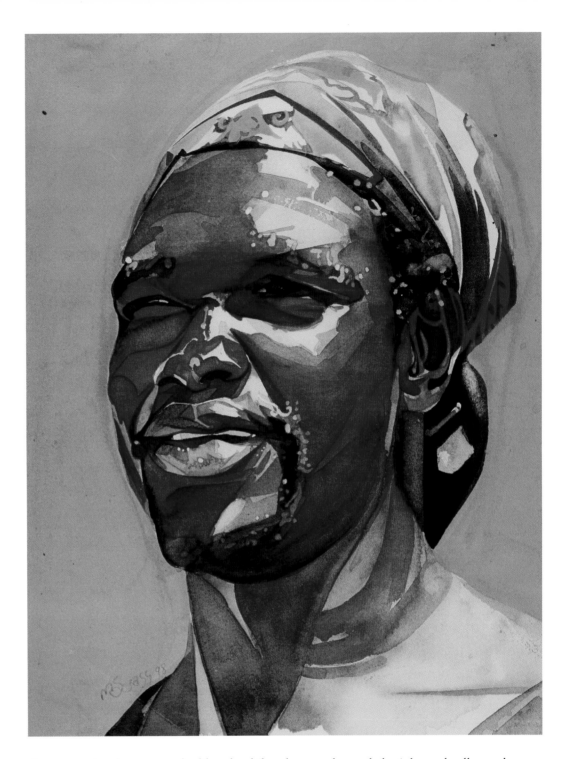

Junie Liburd
watercolour
38 x 28 cm (15 x 11 in)
The skin tones here were
very exciting and challenging
areas to paint.

sienna, need to be generously diluted, while others, such as cobalt violet and yellow ochre, have a low tinting strength.

Additionally, there are various pigments that have a tendency to separate from water when used in a wash, an effect known as granulation. This causes a slight break-up of the surface appearance of the wash – a sort of faint cracking – and it is a characteristic that is sometimes exploited by artists for parts of a painting where they want a grained or textured effect. Colours that have this characteristic include quite a few of the greens and blues, as well as raw sienna and ivory black. If you wish to check on any of these qualities for a particular colour, refer to the manufacturer's colour charts and technical information, which should be available from your art shop or mail-order supplier.

Mixing Colours

In order to mix fresh, unsullied colours, I think it is essential to have plenty of mixing palettes available. If your only mixing area is the lid of a paintbox, for example, there will always be a danger that mixed colours will run together and become spoiled. As explained on page 15, I use large white ceramic plates as palettes – up to ten of them. I place my colours around the rim of the plate and use the central, dipped area for mixing.

I don't abide by any 'rules' as far as the mixing process is concerned, although I think that when you first start using watercolour it is wise to limit the number of colours in a mix to no more than three. With experience, you will find that you can involve more colours than this and still keep the mixed colour fresh and transparent. For example, I might mix a red and a purple and find that it is too strong and needs to be a more subdued, greyer colour. So I would then add a touch of lemon yellow to neutralize and dull the mixed colour, but perhaps only to find that this is still not satisfactory and the colour now needs more red to liven it up.

However, I agree that sometimes this process can go too far and then the only solution is to abandon the mixed colour, which has now become overworked and irredeemable, and start again. It is always important to mix the right colour for each part of the painting, or at least get as near to the desired colour as possible. As we have seen, each colour has an impact on the whole composition, and therefore the 'wrong' colour could significantly alter the mood and effect.

I never use black or white in a painting. If I want a black or a near-black, as in *Black Cockerel* (opposite), I mix a dark green, such as Winsor green, with a violet or blue, or use a green or red mixture and apply this in successive washes until I have the depth of colour I need. My white is generally the unpainted surface of the paper. However, I might occasionally include a white line to separate two colours or, using a spattering or similar technique, add some white to reduce the intensity of a colour.

Green is another contentious colour. I have three greens in my palette and, because many of my paintings have a high colour key, I can often use these in quite a pure form. But I also mix greens. For example, for a rich green I use Winsor green with cobalt blue, and with the addition of yellow, depending on the exact colour and quantity, many variations of green are possible. My colours are generally bright, sometimes too bright! If I need to neutralize a colour that I feel is too strong, I add some raw umber or raw sienna.

Top left: Some of the palettes that I use, showing how I place the selected watercolours around the edge and use the central, dipped area for mixing colours.

Top right: Part of my studio, with work in progress.

Black Cockerel (right)
watercolour
66 x 46 cm (26 x 18 in)
I never use black in a painting. If I want a black or a near-black, I generally use a succession of washes, getting darker and darker, usually with blues, greens or reds.

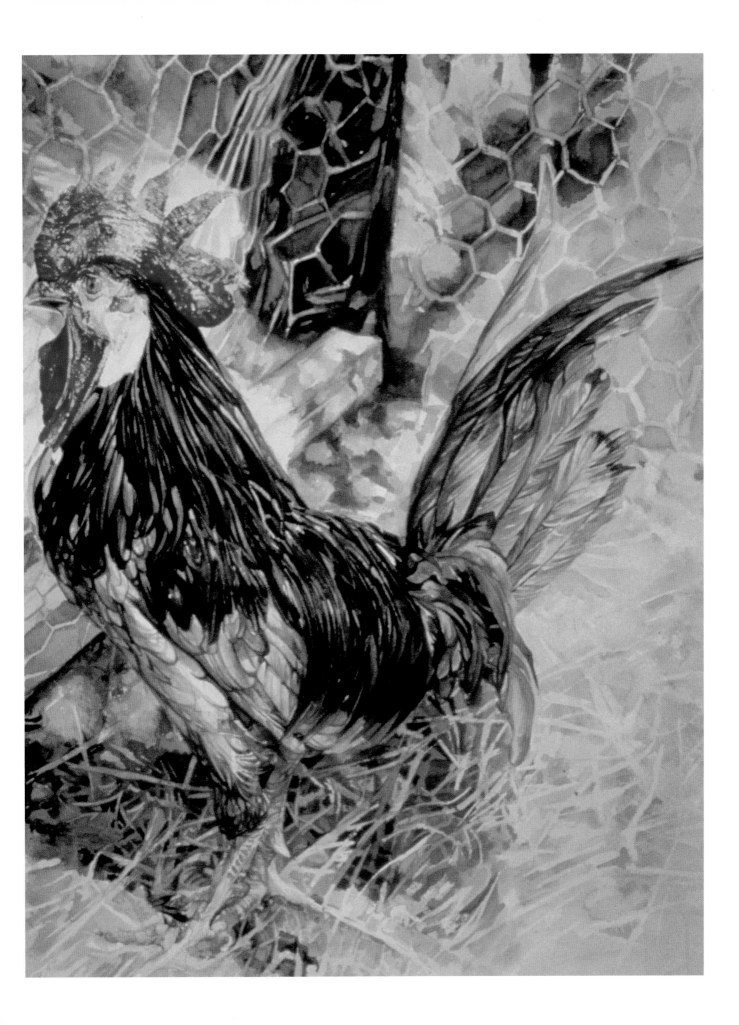

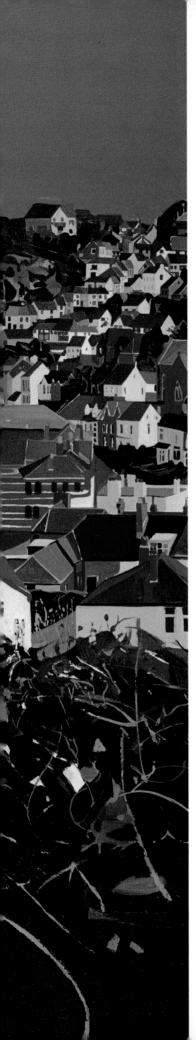

Expression
and Design

3

Design is always a significant element in my work. Whether I am painting a watercolour or busy with a fabric or furniture project, it is the interrelationship between different shapes and colours that interests me and which ultimately will help to create a successful result. In my view, the impact of any piece of work is largely determined by its basic design.

Undoubtedly, my interest in design has been influenced by my art school training and subsequent career path. Paintings were also an influence, of course – I especially like the Scottish Colourists. And my travels to places such as Malaysia, Tuscany and Spain added to my interest in the power of colour and the way that this could be enhanced through strong design. Now, after a lengthy period in my career in which I concentrated on vibrant figurative watercolours, I am returning to work that involves design as the principal issue. My paintings are now more abstract in concept and this has led me to explore ways in which such designs can be applied to fabrics and upholstery.

The Value of Drawing

In many ways, drawing is the most important skill to acquire. Certainly for me, throughout my career, drawing has been the technique that has underpinned all the different aspects and developments in my work. It was important initially, when I painted more traditional watercolours, because it is very difficult to cover up mistakes in watercolour and therefore the underlying drawing must be strong. And it is just as important now that I am more interested in painting abstracts. I still need a starting point, and generally that will be some sort of drawing, albeit a drawing concerned more with spaces and mark-making rather than any representational intention.

Equally, it is through the process of drawing that we learn how to observe and assess those elements of the subject matter that are important, and in consequence are able to convey them in an interesting and informative way. Indeed, even in the age of digital cameras, drawing remains a valuable

Autumn Light
watercolour and acrylic
91.5 x 91.5 cm (36 x 36 in)

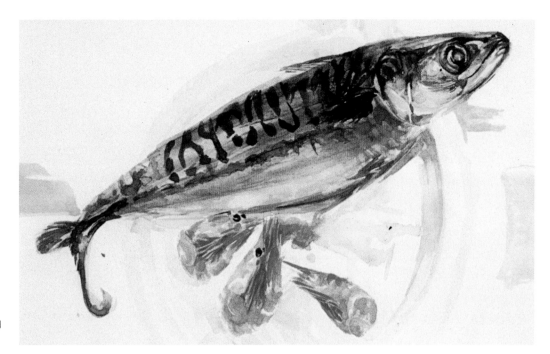

Mackerel
watercolour
48 x 38 cm (19 x 15 in)
The subtleties of colour that can be achieved with watercolour are perfect for carefully observed studies of this type.

means of recording essential information, for it enables us to be selective and to capture our own interpretation of a subject. Drawing can be a rewarding activity in its own right, just as it can play a vital supporting role in every stage of a painting, from the initial planning to the actual painting process. For in fact, when using a brush, we are often drawing – applying brushmarks to delineate and define as well as to add colour, texture and other qualities. See *Reclining Nude* (opposite).

Working from Observation

It usually takes a lot of experience, based on working from observation, before an artist can draw confidently, and certainly before he or she can begin to draw convincingly from memory or imagination. This is how I started. I would set up a still life, often including flowers, and make a drawing of it, perhaps as a preliminary stage towards a textile design, for example. Earlier in my career I also liked to draw and paint outside, directly from the landscape, and this would give me the necessary reference I needed for the more resolved paintings made in the studio.

You might think that, when working from observation, you must make an accurate study of whatever type of subject matter you have chosen. However, this need not be so, although undoubtedly it is the best way to start, when the focus is on improving your basic skills. Inevitably, by attempting to capture a likeness of a subject, as in *Mackerel* (above), with all that this involves in terms of mastering proportions, form, tone and so on, you will, with practice, increase your ability and confidence. But eventually, having gained some experience by working in this way, you will find that you can be more selective in your approach. From the various elements and qualities that you observe in the subject matter, you will be able to select and concentrate on those that you feel are particularly individual and exciting and will make the most interesting drawing or painting.

In time, again due to a depth of experience, the need for detailed reference drawings diminishes, I think. When a drawing is made specifically as a preliminary step towards a painting – to provide information from which to design and develop the painting – it is only necessary to record or suggest those features and elements that will be directly helpful.

Reclining Nude
watercolour wash, charcoal and pastel
35.5 x 29 cm (14 x 11½ in)
Life drawing is an excellent discipline for learning how to observe subjects and master proportion, form and other qualities.

And similarly, once you have some confidence in drawing, and have developed an eye for the qualities to concentrate on, more use can be made of photographs for additional supporting material, without there being any danger of a dependence on the photographs. See also page 69.

I find it more difficult to draw and paint outside now – I must have been less inhibited when I was younger! So, when I do need to go outside for ideas and reference, I adopt a much quicker and more succinct strategy. I concentrate on line drawings to give me the structure and composition I need, and then I either add washes of flat colour to these (perhaps applying a second layer to suggest more depth in places), or I include some touches of colour down the side of the sketch to remind me of the colour palette to use. With the sketches, colour notes and photographs, I have everything I need in terms of reference material for a painting.

Tonal Studies

When using watercolour it is essential to identify the lightest tones in the subject first, and to preserve these at all costs throughout the painting process. If the lightest tones are lost, there is little chance of creating the necessary drama of tonal contrast that will make the painting interesting. Consequently, when I make a drawing or sketch, as I have explained above, I usually add washes of colour to record at least the lightest tones. This is really all I need – it gives me a starting point from which I can then gradually develop the degree of tonal contrast as I think fit.

I prefer to consider tone and colour together, as an integral element within a painting or drawing. As I mix and apply colour, I am thinking about how light or dark in tonal value the colour should be in relation to everything else in the painting. Some artists adopt a different approach and like to start with a tonal drawing made in pencil or charcoal. This helps them assess and plan the tonal values within the subject matter, and it gives them a reliable form of reference to consult as they develop the painting.

Fat Fish
watercolour
25.5 x 43 cm (10 x 17 in)
This painting required a very controlled approach, although I managed to suggest the glistening, scaly character of the fish without resorting to excessive detail.

Autumn Leaves
watercolour
35.5 x 48 cm (14 x 19 in)
Occasionally I will paint something simply for the sheer enjoyment involved in capturing particular colours and textures, as here.

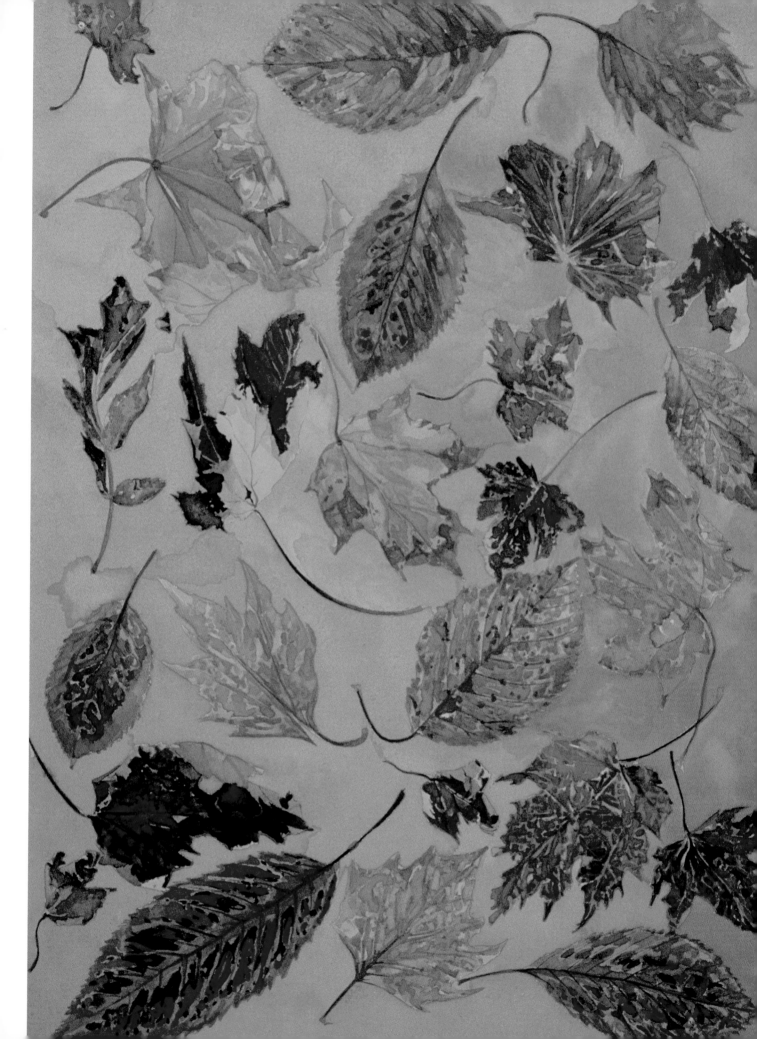

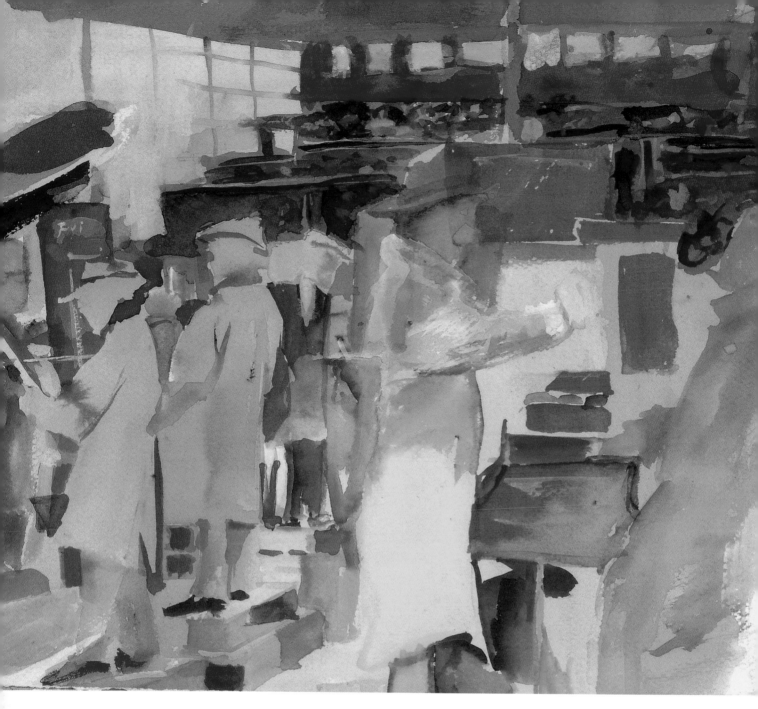

Compositional Roughs

Drawing and sketching are also useful for making compositional roughs. These drawings can be made in pencil, charcoal or a colour medium such as pastel. They will show the format of a composition, indicating the main shapes, usually in fairly general terms and using a linear technique or broadly applied tonal values.

Some artists begin with a series of thumbnail sketches (perhaps measuring just 5 x 7.5 cm / 2 x 3 in) to explore different ideas for a composition and then, having defined the elements they want to include, make a more refined, larger drawing. Others take this process further still and produce a full-scale drawing, which they square up and transfer to watercolour paper. Any lines on the watercolour paper are drawn lightly with a soft pencil, so as not to indent the surface.

I prefer not to use pencil on watercolour paper, because pencil can be rubbed out and changed. Not only does this encourage indecision and fussiness with the marks, but if there

Betting

watercolour and gouache
23 x 28 cm (9 x 11 in)
Providing you are not too
ambitious, it is possible to make
some very useful watercolour
reference sketches on site, as I
did with this racecourse scene.

Prawn (right)
watercolour and pen
10 x 28 cm (4 x 11 in)
Try some studies like this to
help you build up confidence
with the medium.

is a lot of rubbing out it could also damage the surface of the paper and in turn spoil the subsequent wash effects. Instead, I like to draw directly with a brush. I choose a good-quality sable brush with a sharp point that will produce both fine strokes and broad ones, depending on the pressure applied. Drawing with a brush, I think, creates marks that are more in sympathy with the painting. Pencil lines can be very rigid and difficult to combine satisfactorily with colour washes.

I don't usually start with a compositional rough for my floral subjects and similar works: from the outset I work with paint and brushes. However, I quite often make some kind of preliminary drawing for my abstract paintings – not exactly a compositional rough but a starting point to give me ideas to develop in the painting. These drawings might consist of only a few lines freely drawn across a large sheet of paper.

Sketchbooks and Source Material

A good way to practise and improve your drawing technique is to keep a sketchbook and use this regularly to record any subjects and ideas that interest you. A sketchbook is also useful when you want to try out alternative compositions, experiment with techniques and media, and so on. An A4 spiral-bound watercolour pad containing sheets of 300 gsm (140 lb) Not paper will suit watercolours and most drawing techniques. Choose a cartridge paper sketchbook if you want to work more specifically in pencil or pen and ink. Various sizes are available.

Alternatively if – as I do – you find a sketchbook a bit inhibiting, you could work on separate sheets of paper and keep them in a ring-binder or folder of some kind. At this stage in my career I regard a sketchbook principally as a source of reference – a place in which I store anything that could inspire ideas to include or develop in a painting, especially the abstracts. So, for example, I paste into the sketchbook incidental and preliminary drawings that I have made, interesting marks, textures and off-cuts from paintings, and cuttings from magazines. I have also included some wonderful, spontaneous, colourful drawings by my young daughter that are full of energy and vigour, and which I think I will eventually interpret as large abstract paintings; see *Silver Twist* (pages 124–125).

Rickshaw (below right)
gouache
15 x 20.5 cm (6 x 8 in)
Here is another small painting
made entirely on site, this time
using gouache.

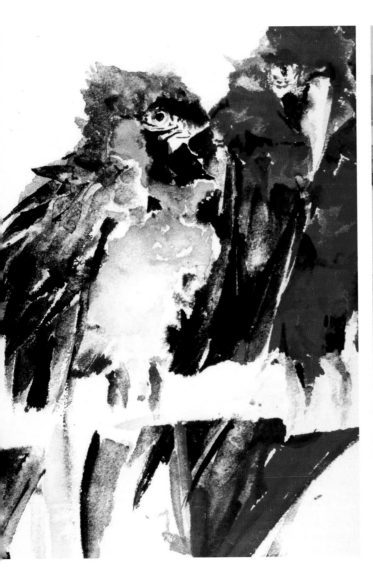

Useful Sketching Techniques

Due to the constraints of time, weather, light and other factors, sketches often have to be made in just a few minutes. Therefore quick decisions are necessary regarding which qualities to focus on and which medium and technique will work best. In fact, a pencil is one of the most reliable and versatile tools. A soft pencil held in different ways and used with variations in pressure will give a wide range of marks and effects. You can use it for both line and tone techniques, for recording detail as well as for a more expressive approach, and for written notes.

Charcoal is excellent for tonal studies, speed and individual expression; pastel can similarly be used with vigour and expression, and is useful for colour reference; black fibre-tip pens are ideal for line drawings; and water-soluble coloured pencils or watercolour paints fit the bill for colour work. However, it is important to note that charcoal and pastel sketches will smudge easily and so ideally they should be sprayed with fixative. My own preference now is either to make a line drawing with colour notes, or to work directly with a few watercolour washes to indicate the main shapes and initial tonal values, as in *Malaysian Market* and *Parrots* (above).

Malaysian Market
watercolour
20.5 x 18 cm (8 x 7 in)
When painting on location with limited time, concentrate on the essential information that you need about the subject.

Parrots
watercolour
35.5 x 28 cm (14 x 11 in)
The main shapes and tonal values are always the first aspects to consider in a subject.

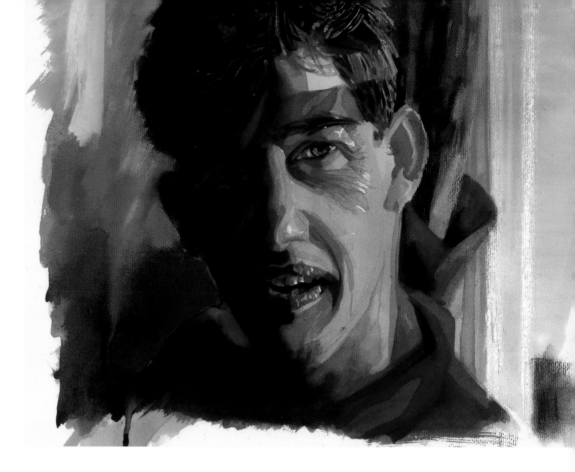

Phil
watercolour and pastel sketch
35.5 x 48 cm (14 x 19 in)
I only had a short amount of
time to compile some reference
information for Phil's portrait, so
I concentrated on this
watercolour and pastel study
and took some photographs.

John
watercolour and pastel
pencil sketch
35.5 x 29 cm (14 x 11½ in)
Here, similarly, the limited
amount of time with the
sitter meant that I had to
start with a sketch.

Photographs as Reference

Photographs can provide an important form of
reference when, for example, it is necessary to include
particular details or capture a good likeness of the
subject, as in a portrait painting. With a portrait, it is
not always possible to paint at length directly from the
person and consequently, as I did when painting the
portraits of Phil and John (above and left), you may
have to work mainly from reference material.
For each of these subjects I made a sketch with colour
notes and then took some photographs.

The photographs gave me all the information
I needed from which to create a likeness, while the
sketch encouraged me to keep the colour and
approach lively and interesting. Actually, I think the
portrait sketches are more exciting than the finished
paintings (see pages 70–71), although obviously the
final works are more resolved as well as being good
examples of my watercolour technique at that time.

I adopt a similar approach for landscapes and some
other subjects. The sketch will give me a starting point
for the eventual painting in the studio, while the
photographs will help to some extent with the
composition, but more particularly with the tonal

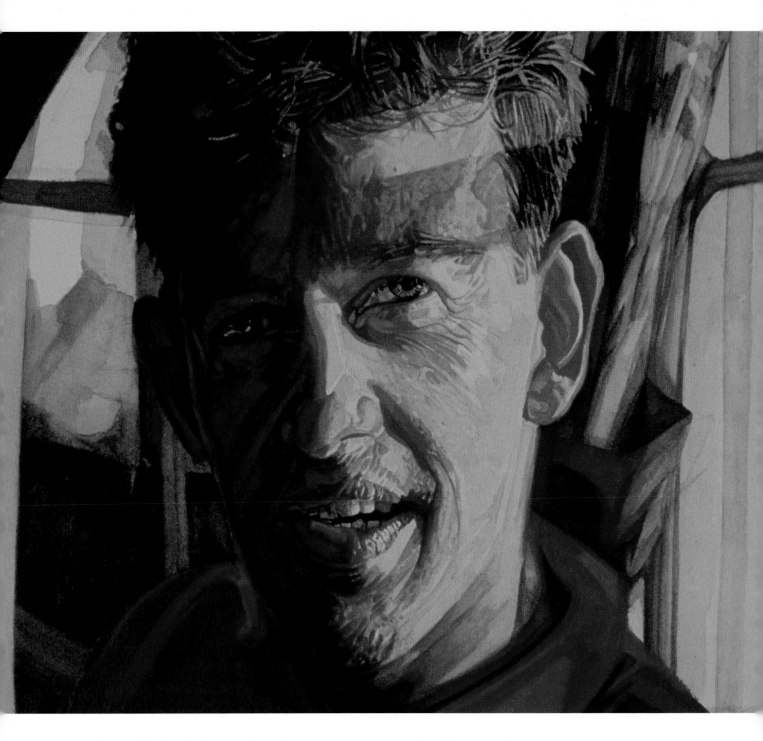

values. Now, with digital photographs and computer programs such as Photoshop, I can reassess the photographs and perhaps enhance the tonal contrasts to give the images more impact.

Also, I sometimes print sections of photographs and make a composite image to work from, by joining the various prints together with Sellotape. It is best to work from several photographs rather than one, because when using a single image there is more of a temptation to copy. Ideally, photographs should be used as a guide and it is your own thoughts, decisions and imagination that should be controlling the work, not the photograph. Moreover, photographs are apt to give a distorted impression of space, scale and perspective, and the colour can be unreliable.

Phil
watercolour
46 x 61 cm (18 x 24 in)
Working from the initial study (see page 69), I was able to make this fully resolved watercolour painting.

John
watercolour
43 x 30.5 cm (17 x 12 in)
The finished portrait, developed from the sketch (see page 69).

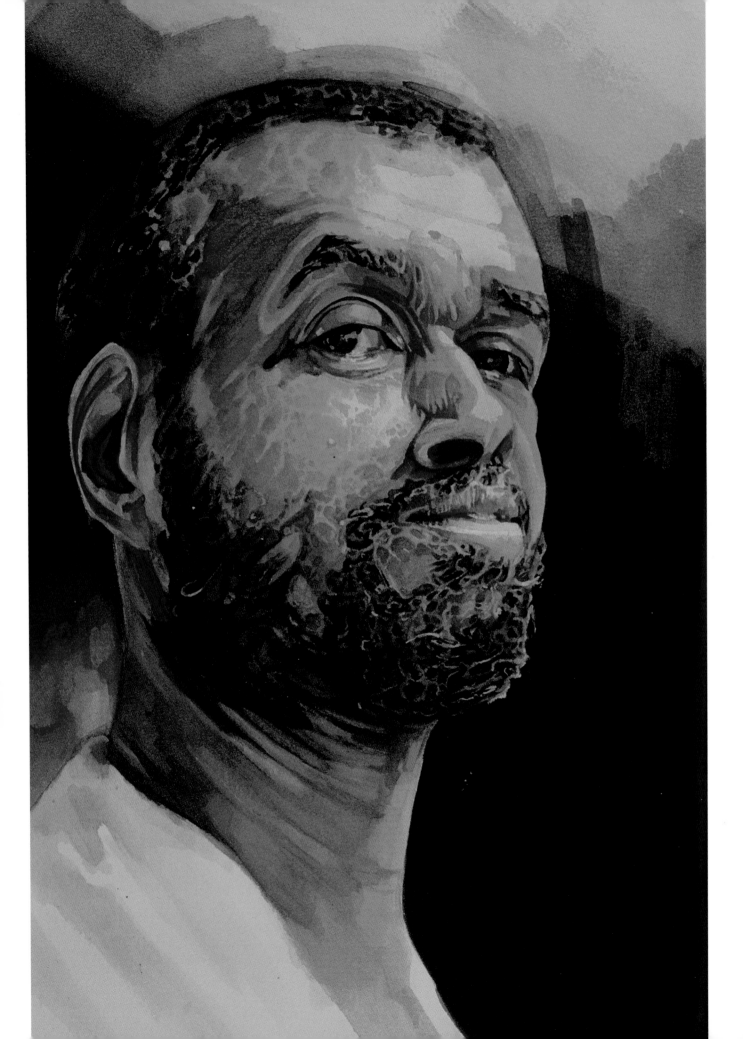

Effective Design

The key elements of good design are rhythms, patterns and colour forms, which essentially I view in terms of proportion and colour. These elements apply as much to the observed, representational work, such as *Feathered Headdress* (left), as they do to my abstract paintings and upholstery designs – see *Exotic Party Chair* (page 78). But particularly with fabrics and furnishings, it is not just the size, shape, placing and relationship of the colour shapes that is important, it is also the rhythm and flow of the decorative pattern, whether this is of a geometric, random or floral nature.

In my watercolour landscapes, flower studies and figurative work the design is invariably influenced by the needs of the painting itself, rather than a compulsion to interpret the subject matter faithfully. Inevitably this encourages a degree of simplification and exaggeration within the selected shapes; overall I want the shapes and colours to work both independently and coherently, so as to generate a rhythm of interest throughout the painting. Success in creating an exciting, effective design naturally relies on experience. As in all aspects of painting, the more work you undertake and the more willing you are to experiment, the more your confidence and knowledge will grow.

Feathered Headdress (left)
watercolour
71 x 30.5 cm (28 x 12 in)
Whatever the subject, effective design relies on using carefully considered shapes and colours.

Resting (right)
watercolour
40.5 x 30.5 cm (16 x 12 in)
I painted this subject more or less as seen, but controlled the amount of detail. Too much detail can detract from the design and, consequently, the impact of a work. Also, note the use of masking fluid for the highlights in the shadows.

Venetian Façade (below)
watercolour
15 x 28 cm (6 x 11 in)
Sometimes, if you find a quiet spot somewhere, you can make very satisfactory, lively little paintings on site, as here.

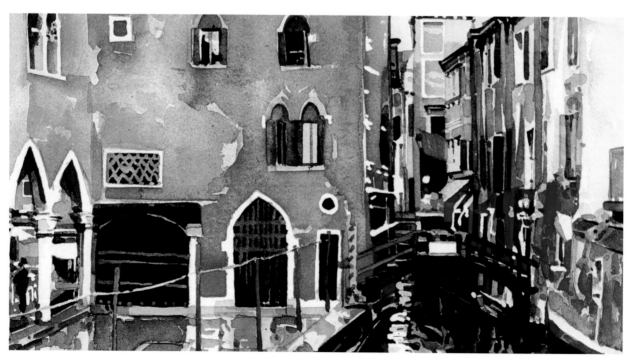

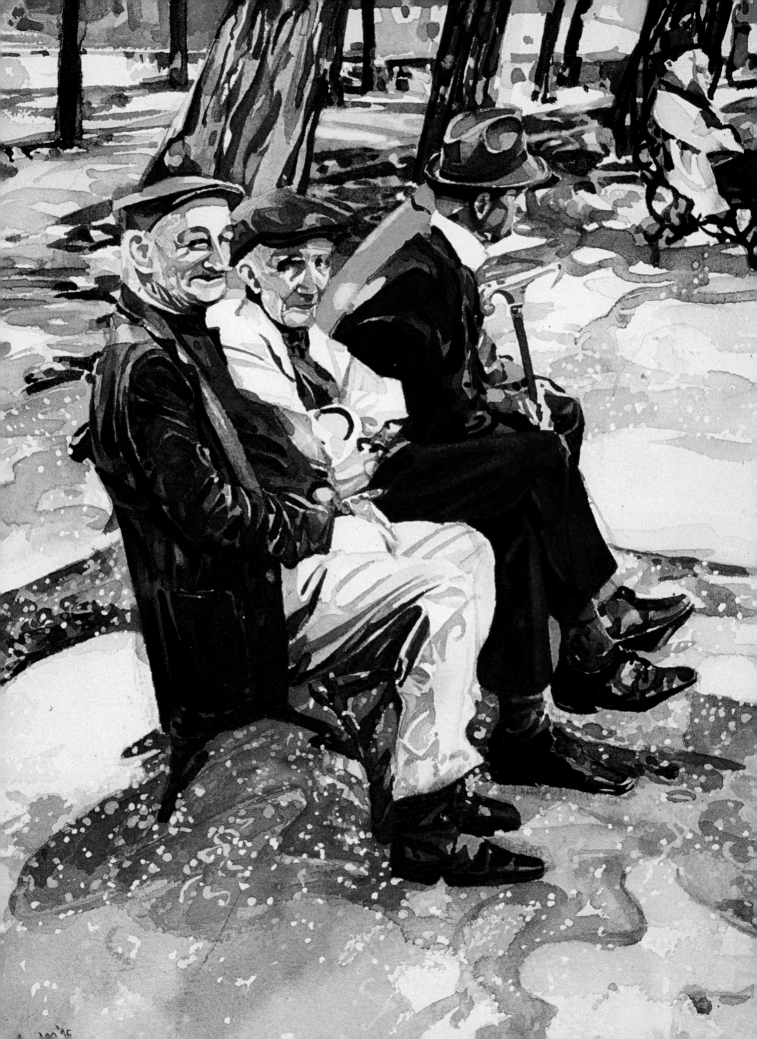

Content and Organization

Picasso valued the confidence, clarity and simplicity of children's drawings and noted that many artists spend their entire lives striving to return to such a way of working. There is a lot of truth in that, I think. It has taken me years to appreciate it, but I now definitely think that 'less is more' when considering content and design.

When we first begin to paint we usually, out of passion and naivety, tend to include far too much. The essence of good design is not to overcomplicate things. You have to learn to leave out distracting detail and, as necessary, select and modify shapes. Ideally the design will fulfil various objectives: it will convey your design concept and, as appropriate, feelings and observations about the subject matter, and it will work successfully both from an aesthetic and a technical point of view.

In my watercolours these points are demonstrated by paintings such as *St David's, Pembrokeshire* (right) in which, as you can see, the power of the design relies on the use of bold, simplified shapes and colours rather than a depiction of the scene exactly as observed. I now mostly concentrate on abstract designs and paintings. However, as I have explained, when I do work in a more representational style I rely on reference material gathered on location – drawings and photographs, which are subsequently pinned up in the studio and used as the information from which to develop a design. Interestingly, earlier in my career I often painted on site, but gradually I have become

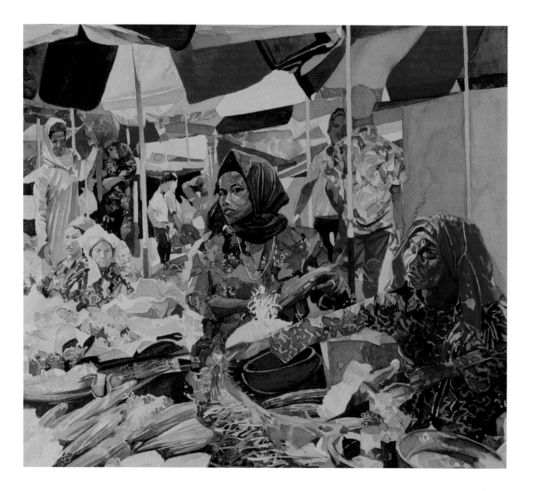

In the Shade
watercolour
33 x 40.5 cm (13 x 16 in)
I liked the way that the vertical poles of the sunshades punctuated this composition and created more formal shapes that contrasted with the busy area below.

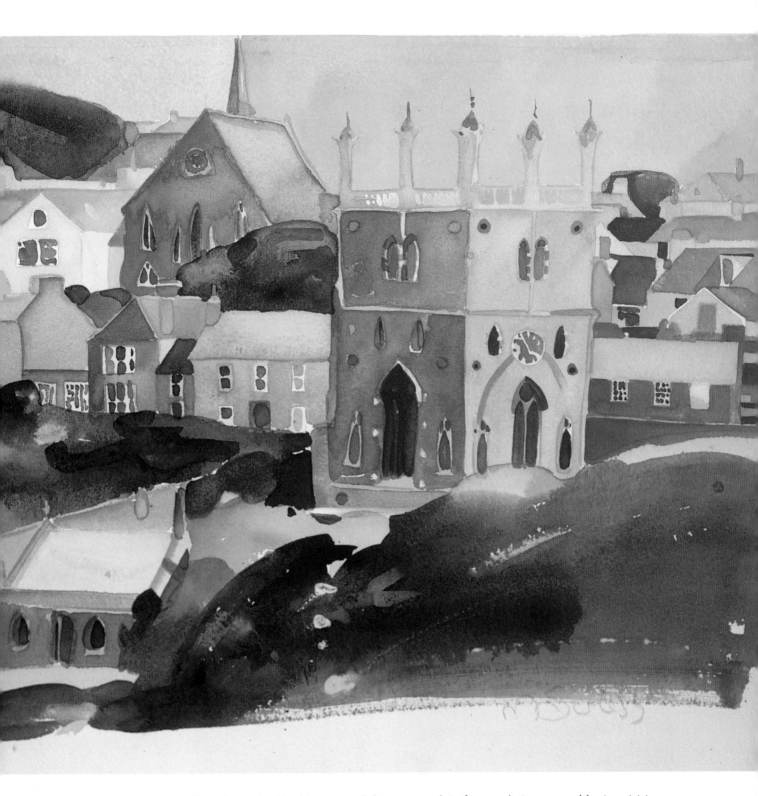

St David's, Pembrokeshire
watercolour
39 x 62 cm (15½ x 24½ in)
Here again I have simplified the content and focused on bold shapes and colours.

disenchanted with this approach because work is frequently interrupted by inquisitive passers-by, which is very distracting.

With the location sketches and photographs I include colour notes, which provide a guide for mixing the right colours in the studio. For *St David's, Pembrokeshire*, for example, the colour references included the specific slate blues and foreground greens. After I had lightly sketched in the basic design for this subject on watercolour paper, I then blocked in everything with colour, working initially with thin, translucent washes of paint. From there on, with the design now established, the emphasis was on colour.

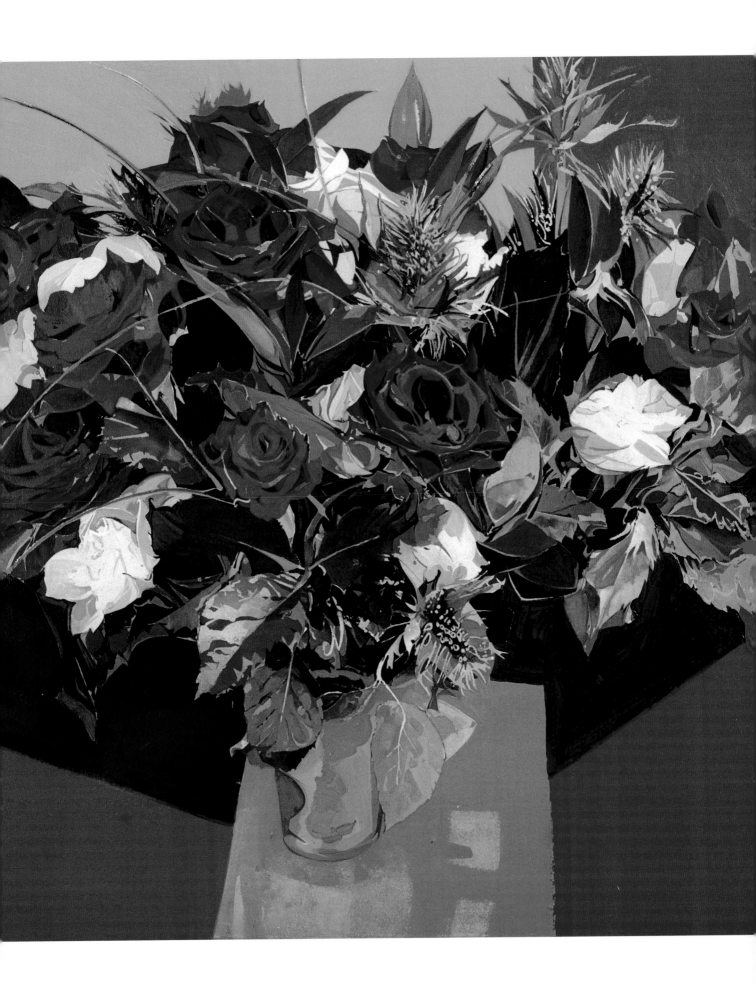

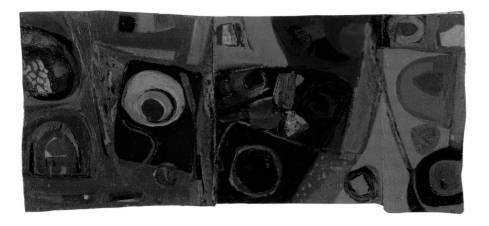

Farewell (left)
watercolour and acrylic
91.5 x 91.5 cm (36 x 36 in)
While contrasts of shape
and colour are essential,
equally the painting must
have a coherence and
rhythm so that it 'reads'
effectively.

Delicious Water (above)
watercolour and acrylic
25.5 x 63.5 cm (10 x 25 in)
Particularly with abstract
designs, it is very important
to consider the relative value
of each of the different
elements involved and how
they interrelate.

Relative Values

Contrast and harmony are other factors that influence the success and character of a design. While much depends on the context and intention – some fabric designs might need to be quite subtle and restrained in effect, for example – generally a degree of contrast is necessary in order to enliven and add impact to the final image. Therefore, always an important aspect of design work is the consideration of the relative value of each of the various elements involved – the size of one shape in relation to another, the choice and strength of one colour against the next, and so on. Such contrasts and harmonies will visually enrich the design, but at the same time it must have a coherence and rhythm, so that it 'reads' well.

In fabrics, the integrity of the design often relies on pattern and repeat techniques. In a painting, however, while these techniques might be involved to an extent, the underlying design or composition usually requires a quite different approach in order to create an image that has vitality and drama yet is equally successful in maintaining the viewer's interest within the bounds of the work. When making a painting, there is sometimes a strong sense of design inherent in the chosen subject matter and so very little is required in the way of selection, emphasis and reorganization. At other times the subject matter needs a greater level of editing and manipulation if it is to work as an effective design. And another key factor, of course, is the personal response of the artist. Essentially, the content of the painting, and consequently its chosen design, will result from those qualities within the subject matter that most impress and therefore must be included and expressed.

Another point about good design is that it should never feel imposed or contrived. Nevertheless, an intuitive approach is not always the best. There are various theories and conventions that can help in creating a design that works successfully, particularly if these are used with discretion. In paintings, generally speaking the most successful compositions are those in which there are areas to rest the eye as well as areas of interest. And in most paintings the design is developed around a particularly strong feature, focal point or centre of interest within the work. I remember studying the principles of design while I was at college and I believe this knowledge and practice is just as relevant to my work today: indeed I think it is more so.

One of the most widely used of these design principles is to divide the picture area into thirds and then position the main feature of the painting – the centre of interest – at a point about one-third or two-thirds across the paper or canvas support. This division, which is actually based on the Golden Section (a proportion found in nature, which can be expressed approximately as a ratio of 5:8), works equally well whether applied in a horizontal or vertical direction. It seems to create just the right degree of balance and contrast in a painting, whereas those designs in which the main elements are symmetrical or evenly balanced tend to be far less effective. Designs using a diagonal or triangular division of the picture surface also tend to work successfully, as do those based on a 'Z' or 'S' shape.

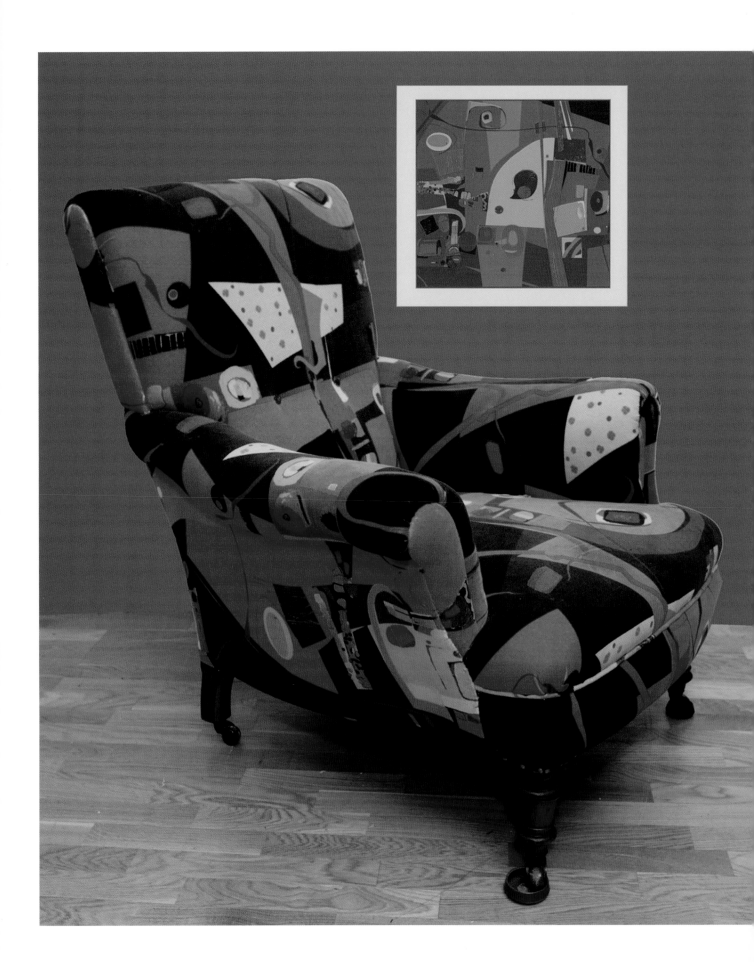

Fabric Design and Illustration

4

At Glasgow School of Art I studied printed textiles and my first job was as a fabric colourist for Osborne & Little. Throughout my career I have been fascinated with the interrelationship between painting and design. For me, this has been a very natural relationship and means of working, with the paintings sometimes inspiring fabric designs and, especially more recently, the sense of rhythm, colour and pattern inherent in a fabric design creating ideas for abstract paintings.

Some time ago I did some large watercolours of cockerels and hens in which, as a way of interpreting the tail feathers of these birds, I used a layering technique (in effect, glazes of different colours) to create the contrasts of tones and colours. I added other flashes of colour to convey the effect of light and reflections. For example, the tail of a Japanese cockerel might be predominantly a rich blue, but with touches of green running through it and, when you look really closely, also streaks of pink. These colourful, decorative feathers gave me an idea for some textile designs, one of which was *Duck Feathers* (page 80).

On another occasion I made a series of paintings of people in Malaysia, again viewing them in relation to their environment. These paintings inevitably involved a lot of bright colour and rich patterns, which subsequently inspired various fabric designs. As with the cockerel paintings, this demonstrates how one form of expression can readily lead to another, and indeed how painting and design are inextricably linked.

I look for colour, space and texture in an area of a painting that I think will translate into a fabric design. The painting may suggest a colour scheme that will suit the fabric, and it may also suggest some kind of geometric shapes, curves, sweeping lines or a similar motif that will make an exciting repeat pattern. Now, with the aid of different computer programs, I can isolate an area of a painting and convert this into a design for fabric, as in *Shirt Floral* (below), for example. And perhaps later on I find myself making a painting from the fabric – thus taking the process full circle!

Exotic Party Chair

With fabric, it is important to create a rhythm and flow with the decorative pattern and, when this is used for upholstery, to ensure that it is sympathetic to the underlying form of the furniture.

Shirt Floral

watercolour textile design
20.5 x 25.5 cm (8 x 10 in)
I now mostly work on a computer, in Photoshop, using a digital image of a painting and adapting part of it to create a suitable design for fabric printing.

Poppies

silk scarf, from a watercolour design

91 x 91cm (36 x 36in)

I started my career as a fabric colourist, and I still enjoy the challenge of making bold and colourful fabric designs.

Duck Feathers

watercolour textile design

40.5 x 35.5 cm (16 x 14 in)

Nature is full of ideas for exciting pattern and design work, as here.

Furnishing Fabrics

With my watercolour paintings of landscapes, flowers, animals and other subjects, I have gradually learned to eliminate detail and rely on bold design. Recently, I have taken this process further and am concentrating increasingly on paintings in which shape and colour are the main considerations. In turn this has prompted me to experiment with ways in which these essentially abstract designs can be adapted and developed to suit other types of creative work including the design of furnishing fabrics. There seems to be enormous potential for exploring new ideas in this context, and I am very excited at the prospect.

Starting Points

For this type of fabric design I start by selecting one of my abstract paintings that has the right qualities – for example it is not too complicated, and there are elements that will suit a repeat effect. Then there are two possible methods of working: either using the conventional studio method or (much quicker) developing the design on my computer.

If I use the studio method, because I do not wish to damage the original painting I either paint another version or I make some colour photocopies of it. Then I begin the design process by cutting one of the copies in half horizontally and reversing the two sections, so that the top edges are now in the middle and the cut edges become the top and bottom of the design. I tape these two halves together with masking tape and then I repeat the process in the other direction, cutting the design vertically, twisting the pieces around so that the cut edges become the outer edges, and then once again taping the design back together.

This process creates a design that will repeat perfectly both sideways and top to bottom. However, obviously the central joined areas require attention to ensure that the design works as a coherent whole rather than appearing as four disjointed parts. So it is generally a matter

Poppy Two-Seater

When applied to furniture, the fabric design has to be further adapted so that it fits the form and shape of the piece.

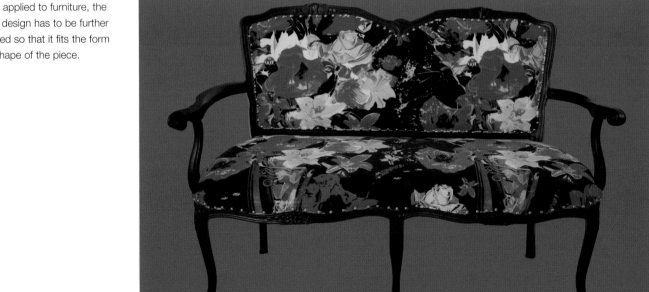

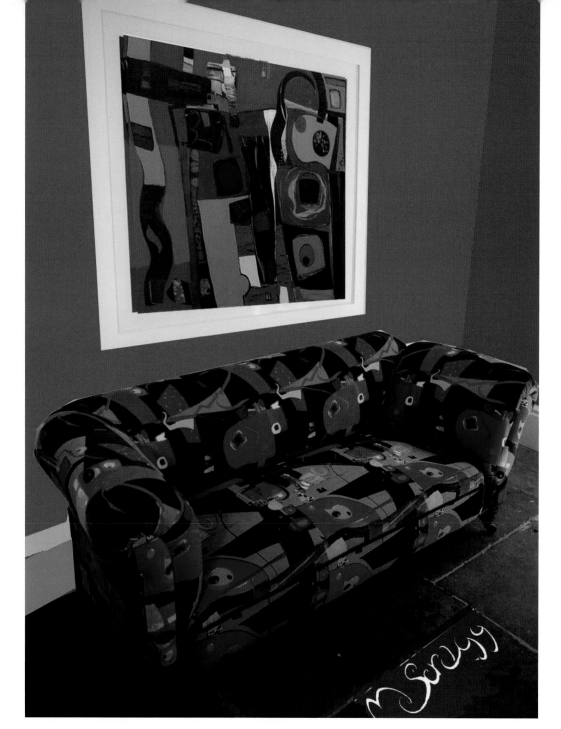

of doing some further painting and modifications to these areas. Then I pin up the
reconstructed design on my studio wall and see what I think. It may need further work to
quieten down some areas or enhance others. As necessary, I experiment with paint, pastels or
pieces of cut paper to block out areas or add shapes. When I am satisfied with the design, I
repaint it and then it is photographed and processed ready for the actual fabric printing.

In fact, now I do most of this work on my computer, using the Photoshop program. As I
have mentioned, this is far quicker and it has the advantage that I can experiment with scale
as well as different colourways. The final design is put on a disk and sent off to the company
that prints my fabrics. They will produce a sample printed piece of fabric, perhaps just a
metre or so, and from this I check the colours and quality so that any adjustments can be
made before the final printing. The fabric used for *Poppy Two-Seater* (page 81) is an example
of this process.

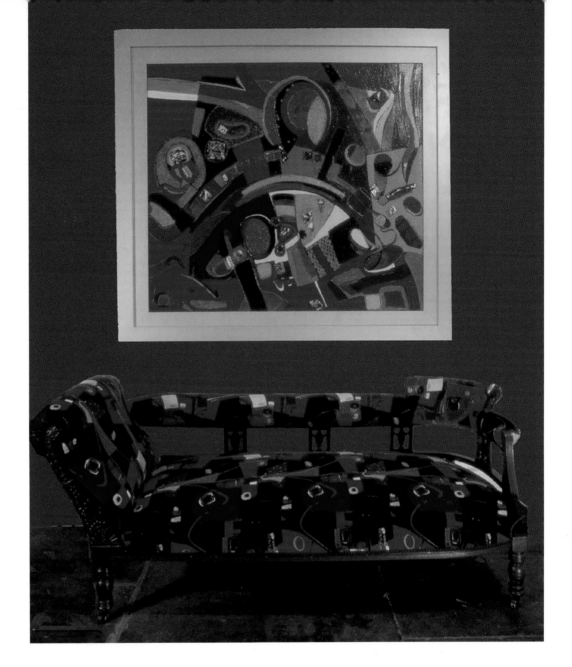

Red Party Chaise
For my fabric designs I source traditional forms of furniture like this, strip each one back to the carcass, and then renovate it as necessary before applying the printed fabric upholstery.

Applications

I like the connection between the original painting and the repeated design that is developed from it. But rather than simply interpret the design as lengths of printed fabric I am interested in taking this a stage further and exploring how, by printing a design on cotton, velvet or other specially treated fabrics, it can be used as an upholstery material to cover various items of furniture. I aim to offer this as a bespoke service to clients, as a combined painting/furniture project, working to an agreed colour scheme.

This involves an additional process on the computer in which I further adapt the design so that it will suit the shape and form of the specific piece of furniture. Thus the design considerations become more sculptural and three-dimensional. At present I am sourcing traditional forms of furniture, as in *Red Party Chaise* (above), stripping these back to the bare wood and doing all the necessary painting and preparation of the carcass ready for the upholstery. And there are other exciting ideas that I am working on, for instance abstract paintings that incorporate glass shapes and incised lines filled with clear resin, and similarly adapting this process for furniture.

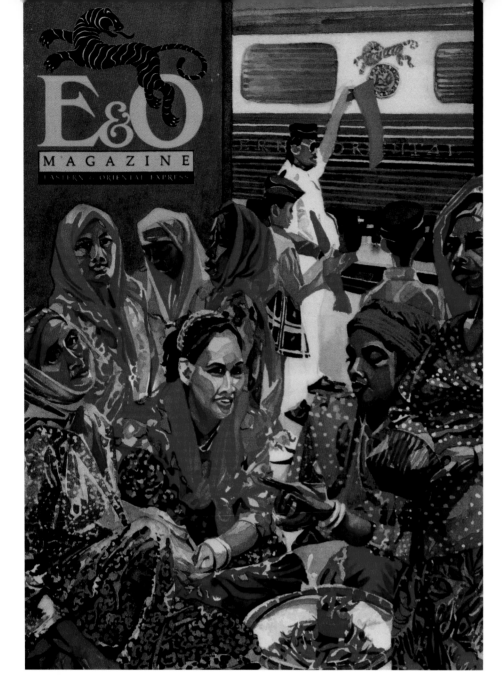

Watercolour and Illustration

At different times in my career I have undertaken illustration commissions, and for these I would use watercolour or gouache, depending on the nature of the work and the effects required. Watercolour is an excellent medium for illustration projects, because not only will it give rich, lively colour quality, but also a good range of tonal values together with subtle blends and variations of colour. This is why, for example, watercolour is often used for the original artwork for children's books.

Gouache is the traditional designer's medium and it particularly suits artwork in which flat, opaque colour is needed, for example when working on fabric designs. However, it is much more difficult to achieve strong tonal variations with gouache and, without due care, the colours can easily become muddy. There are times when it is an advantage to use both watercolour and gouache in the same design, perhaps exploiting the essential purity and translucency of watercolour in some areas and, in others, choosing gouache to create calmer, simple colour shapes.

Essential Elements

Successful graphic and illustration work relies on making a clear visual statement in a confident and interesting way. It is important to focus on the specific brief or objectives for the project, the theme or narrative involved, and express this coherently yet simply, without too much detail. If some detail is felt necessary, it is usually more effective if this is confined to a small, concentrated area.

With illustration commissions (and equally this could apply to projects that you have chosen yourself), the concept and content of the work has to be carefully considered, planned and organized from the very beginning. In this respect, the process is quite different from that

All-Day Market
watercolour
23 x 38 cm (9 x 15 in)
In Malaysia I was particularly impressed by groups of women in bright clothes. They made wonderful subjects to paint.

of making a painting, in which the work is being reassessed and adjusted the whole time. However, with an illustration project, once the design has been approved, it is then purely a matter of faithfully reproducing that design by applying the appropriate skills and techniques.

There is an additional factor when working on an illustration project for a client, in that the client will set guidelines and expect you to abide by these. The client will want to see preliminary designs for approval and thereafter have an input into the process at every stage. It can be difficult to accommodate someone else's ideas in something you have created!

Reclining Figure
black ink and gouache
33 x 51 cm (13 x 20 in)
The lines in this drawing were made with a permanent black pen and then I added some colour reference in gouache.

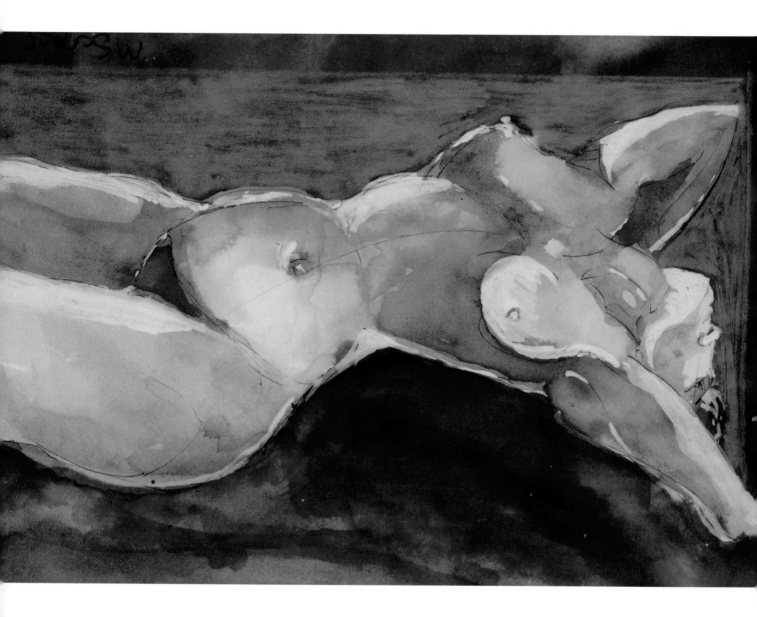

Line and Wash

Nude in Blue
pen, watercolour and pastel
12.5 x 23 cm (5 x 9 in)
Here I made one or two
pen lines to start with, but
this is principally a tonal
wash drawing.

Early in its history, watercolour was widely used to tint topographical prints and drawings, and this technique, involving line and wash, is one that remains useful and effective today. There are two methods of working: you can either begin with a line drawing and then add weak washes of colour to this; or you can start with general areas of colour and subsequently add greater definition with some linear work.

The lines can be drawn with pencils, water-soluble coloured pencils, pens, charcoal or with a brush. Obviously, each medium will give a different quality of line, while other more dramatic or diffused effects are possible if the drawing medium is applied directly over the wet wash. As well as watercolour, I sometimes use gouache or acrylic inks for colour washes, as demonstrated in *Reclining Figure* (opposite). See also *Prawn* (page 67), which I started with a drawing made with a black Rotring pen, before adding orange and yellow colour washes. When the paint had dried I did some more drawing with the pen to suggest the texture and detail.

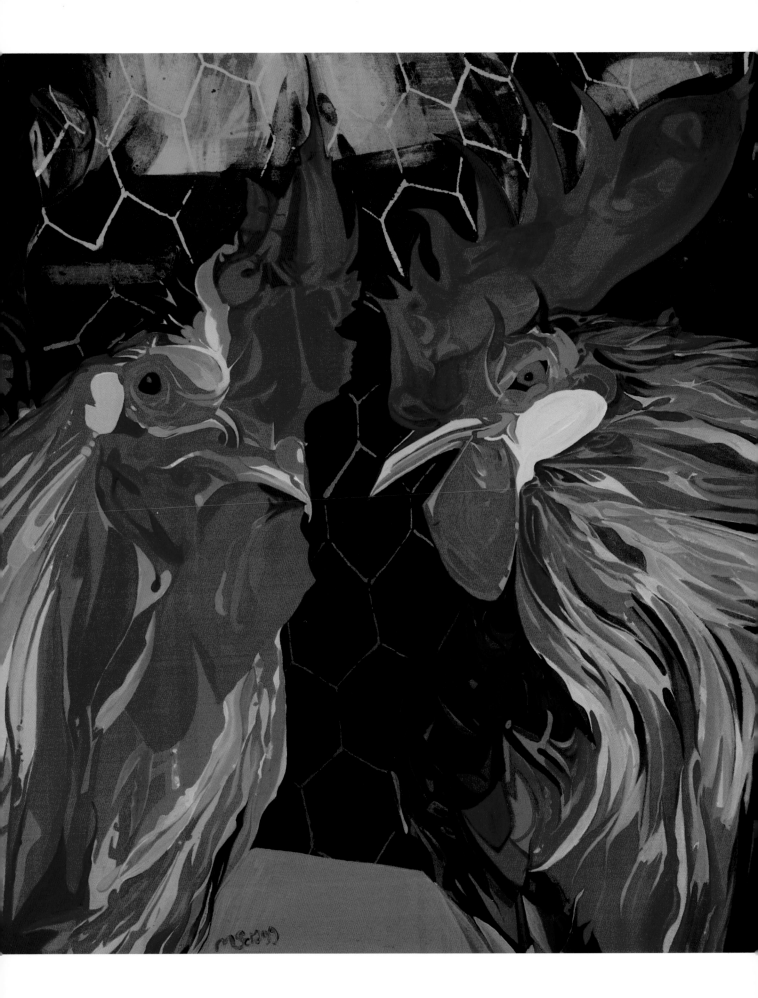

Interpretation

Whether descriptive or abstract, I believe every painting must involve an emotional response, and as well as initiating and conveying such a reaction from me, it should similarly touch the feelings and sensitivities of those who subsequently view the work. In my opinion, as much as paintings are about colour, the impact of composition, surface qualities and so on, they are equally concerned with feelings.

Naturally, the degree of emotional response invested in a painting will be directly influenced by the chosen subject matter or idea, for it is difficult to work convincingly and with enthusiasm if the subject does not excite you in some way. Indeed, pursuing an idea without that enthusiasm is almost bound to result in work that looks non-committal and dull. Painting is essentially concerned with individual interpretation and expression, and in turn it inevitably reflects the depth of feeling that you have for each idea and the strength of your desire to paint it.

Feeling and Response

For me, the emotional response is usually sparked off by seeing a particular colour or colour relationship. For example, when I was in the Caribbean I met a woman carrying a brilliantly coloured bag on her head, and this image was so striking that I asked her if I could make a sketch. She was reluctant about the sketch, although she did allow me to take some photographs. I used these for a painting, which in turn led to a whole series of portraits, mostly of Caribbean women. Another fascinating aspect of this experience was painting the dark skin colour, which I found was full of rich tones and varied reflected colours that added to the interest of each portrait. Often, something will trigger off a whole series of related paintings in this way.

At other times the initial idea and emotional response does not come from something real and observed, but rather from my imagination. Usually it is an idea that evolves and becomes more exciting and inspirational over a period of weeks. Then I might rough out something in sketch form first, or go directly into the painting, which again will probably lead me to explore other versions and developments.

I have always liked the wonderful colours and characteristics of cockerels and, as you can see with *Handsome Cockerel* (page 90), these birds make really exciting subjects to paint. I felt that this particular painting was very successful because it has a lovely fresh, energetic quality expressed in the traditional watercolour way, with sensitive brushstrokes and freely applied colour washes. The brushes were right, the watercolour flowed well and I managed to build up enough tonal contrast to create the impact, yet keep the painting lively and not overworked. Also, I felt that I had been successful in capturing the feeling of colour and form that I had in mind. See also *Love Match* (opposite) and *Speckled Cock and Hen* (page 107).

Love Match
watercolour and acrylic
91.5 x 91.5 cm (36 x 36 in)

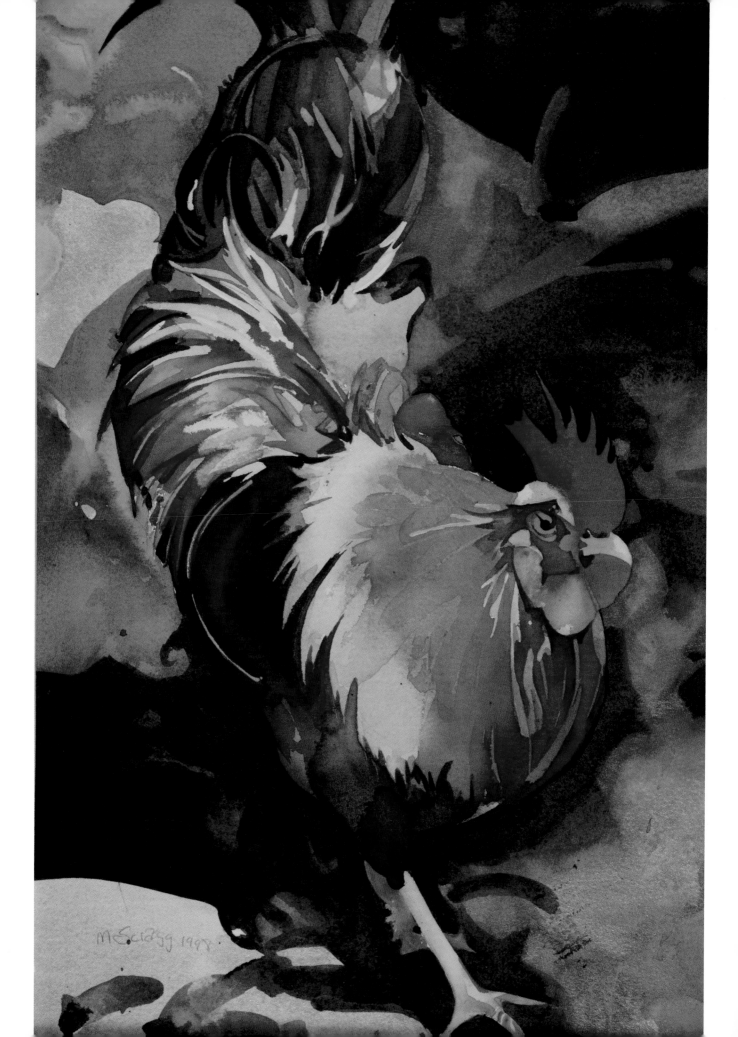
M.Scragg 1998.

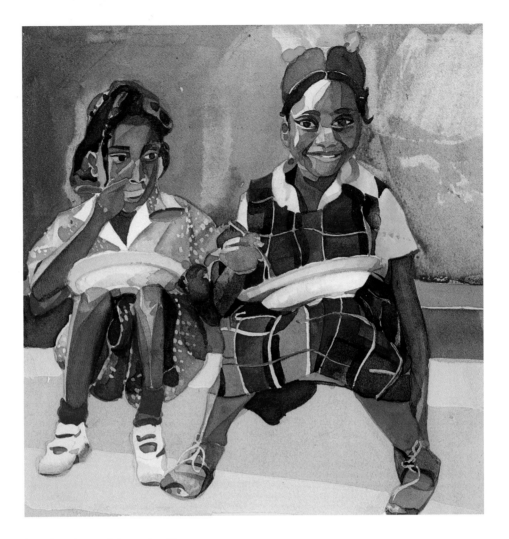

Ice Cream (right)
watercolour
40.5 x 40.5 cm (16 x 16 in)
Here again, it was not so much the subject matter that attracted me, as the potential to explore different colour contrasts and harmonies. The texture in the background was made by wetting areas and then lifting out some of the colour using tissue paper.

Handsome Cockerel
watercolour
43 x 25.5 cm (17 x 10 in)
I was particularly pleased with this painting: it seemed to work extremely well, with exactly the fresh, energetic quality of colour and tone that I strive for.

Instinct and Inspiration

It would not be long, I think, before anyone viewing my work would conclude that my inspiration is colour! In a sense, the subject matter is immaterial: I am quite happy to paint anything if there is the potential to explore colour relationships and create exciting colour contrasts and harmonies. Look at *Ice Cream* (above) and *Venetian Arch* (page 92), for example. These are very different subjects, but both attracted me because of the opportunities they offer to exploit the power of colour.

Often when I am out I come across a landscape or a city scene that I instinctively feel will make a good subject. Perhaps the landscape is predominantly one colour but has little touches of contrasting, vibrant colour within it. Or, in a city scene, perhaps there are buildings with different shapes and colours that create a powerful interaction of colours. These are the types of subjects that attract my attention; I will make a mental note and return to them later, when I have time to make a brief sketch and take some photographs.

My approach to studio work is similar. I do not set up anything unless I have an exciting idea in mind. I love painting flowers, but I still need that spark of inspiration, and obviously this is very much tied in with the emotive response described earlier. For instance, if I pass a florist's shop and there are some beautiful irises in the window that I feel I must paint, that is my starting point. Then I will look for a suitable vase and perhaps other, contrasting flowers that will add to the impact of the arrangement. Alternatively, I might be in someone's house and notice a very interesting vase that I can visualize in a painting with certain varieties of flowers, and so I develop an idea from that.

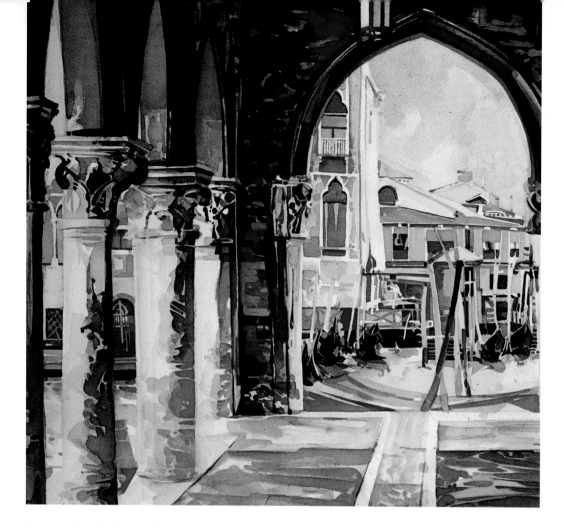

Assessing Ideas

While it is vital to feel inspired by an idea and eager to get started on the work, you have to balance your excitement and enthusiasm with clear aims for the painting. Ideally you will want to create the distinctive crispness and freshness of colour that only watercolour can offer, but at the same time you must think about which approaches and techniques will be most suitable. Equally, although it is wise to be ambitious in your objectives, for this will undoubtedly help your work improve, it is best to avoid ideas and processes that you know are well beyond your level of skill.

Rushing into a painting without some thought and objectives invariably leads to disappointment. This is not to say that the painting must be planned to the last detail, of course, but rather you should know roughly what it is that you want to achieve. With experience, the process of assessing an idea becomes second nature – intuitive and fairly quick. But to begin with you may need to make a more calculated judgement about how you want to develop the painting. Start by asking yourself which aspects of the subject matter are the most important and how you intend to interpret them, which colours will be the most suitable, and what format to use – the size and shape of the painting. To help you clarify these points, you may find it helpful to make some sketches first.

Creating Impact

I rarely use colour applied wet-against-wet or wet-into-wet (see page 27), and therefore the washes are kept pure and clearly defined, without any blurring or fusion of colour around the edges of each shape. For me, this technique of working is vital in order to create the sort of

Venetian Arch
watercolour
48 x 46 cm (19 x 18 in)
In this subject I decided to emphasize the strong shadow area to create a dramatic tonal contrast in comparison to the view beyond.

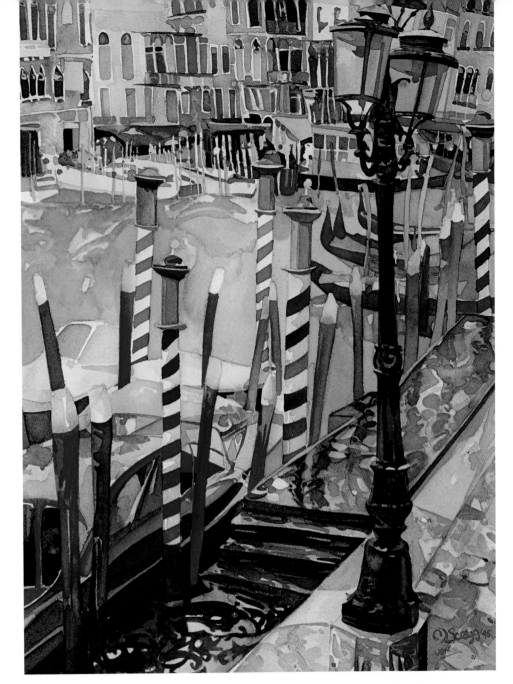

Striped Poles, Venice
watercolour
40.5 x 28 cm (16 x 11 in)
This is a good example of the way I sometimes build up significant areas of a painting with small blocks of colour. If considered in isolation, these areas have an almost abstract quality.

impact I require through the use of fresh, vibrant colour. And it is the design that underpins this impact: I am very particular about the drawing of the various shapes and how they interrelate. Essentially I am aiming for a play of line, shape, space and colour.

I think the hardest thing to learn is definitely proportion, by which I mean how to judge the balance of shapes and spaces that make up a painting. The spaces are just as important – sometimes more important than the actual shapes of the subject matter, and they have to work effectively as areas of rest and contrast within the composition.

You can see in *Striped Poles, Venice* (above), for example, that apart from the foreground boat and lamp standard, the painting has been developed with a series of simple blocks of colour, including a particularly passive area, the water, which is simply a broad wash of turquoise blue. Interestingly, if you can imagine the boat and lamp standard taken away, the rest of the painting is quite abstract. I think this proves that you do not have to include every detail in a painting for it to 'read' effectively. Often, the impact and overall sense of a painting owe more to inference and suggestion – and thus to the viewer's imagination – than to detailed representation.

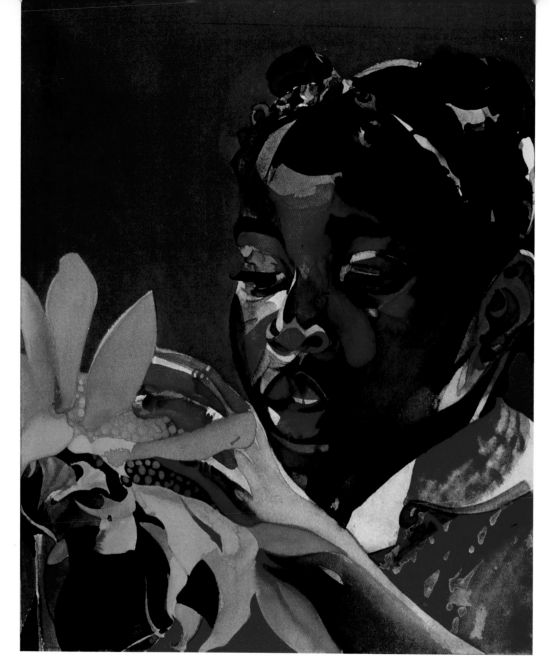

Observation and Imagination

Observation, as I have already discussed (see page 63), is generally the starting point for an idea and, of course, it is an essential part of learning to draw. In my view, it remains a necessary discipline, irrespective of experience and working methods. In fact, my work is now far less governed by direct reference to the subject matter: there is a much greater element of imagination and personal interpretation. Nevertheless, observation still plays an important role, for it helps to create a sort of balance in my work. It prevents my imagination running riot! I like the fact that by working with a combination of observation and freedom of expression, my imagination is kept within certain bounds. In turn, this helps create a sense of order in the paintings, and it prevents them from becoming just a hotchpotch of ideas.

Working Without Preconceptions

One of the difficulties, when working from observation – and sometimes even when developing ideas from imagination – is avoiding preconceptions about the various objects

Sunflower, Nevis
watercolour
23 x 18 cm (9 x 7 in)
Observation is always the
starting point for a painting of
this type, but I never feel that I
have to express what I see in
a totally literal way.

and colours that you want to include in the painting. It is easy to assume that the grass is green or the sky is blue, whereas in fact there could well be many variations of colour in these areas, or particular colour features that are worth exaggerating and which will make the painting more interesting. Similarly, you might think that every building must conform to the rules of perspective or that figures must fit certain accepted proportions, and so on.

Therefore a key skill to develop is the ability to observe in an unbiased, open-minded way the qualities that are distinctive and individual about each new subject matter. While you need not reject the knowledge that you have built up from painting similar subjects in the past, look for features that are different and special in the present subject, and which you can subsequently reveal in the painting. An important requirement of any painting is that it is original and engaging. However, this cannot be so if you make assumptions about the subject matter and fail to capitalize on its main strengths and characteristics.

Colour, in particular, is an aspect of the working process that is open to preconceptions. Yet there is no need to feel restricted by the colours that you find in a subject. My advice is to look for a colour that will give an interesting focus for the painting and aim to build an exciting sequence of colour relationships around that.

Individual Interpretation

My paintings are becoming increasingly abstract and therefore the starting point is less likely to be something observed. However, I have enjoyed many years of painting in an essentially representational way and I still relish the challenge of this type of work occasionally. In my experience, there are two key points to stress about working directly from a subject: do not feel compelled to paint exactly what you see, and do not be afraid to stress the features and qualities that, for you, make the subject special and inspirational.

By emphasizing these aspects, you will give each watercolour its own identity and at the same time gradually establish your own style of painting. Undoubtedly, a feature of my style is the use of patches and shapes of pure – though not necessarily realistic – colours to build up each image. Look at *Pink Sky* (pages 96–97). Here, the content is recognizable but, as you can see, its success relies more on carefully judged drawing, design and colour relationships than on a concern for accurate representation and detail.

I suppose every artist would like to establish a style that, at a glance, distinguishes and defines their work, and understandably sometimes there is a temptation to want to speed up that process and become 'recognized'. However, style is not something that you can hasten or deliberately manufacture in some way. To have impact and integrity, your style needs to evolve slowly; it will come by virtue of sheer hard work. In my view, the best approach is to paint without any concern for style – just let it happen.

An associated point, here, is the question of influences and whether it is helpful for beginners to copy other artists' work. Copying something can be a useful means of learning a new technique, and similarly viewing a painting at an exhibition will sometimes trigger a fresh development in your work or suggest new ideas to explore. Certainly, for me there have been a number of exhibitions that have had a very positive effect on my work, especially those featuring the 'Glasgow Boys', Gauguin and Japanese art. So, by all means copy something if you think it will help you make progress, but keep in mind that ultimately you need to stamp your own interpretation and style on the subjects that you paint.

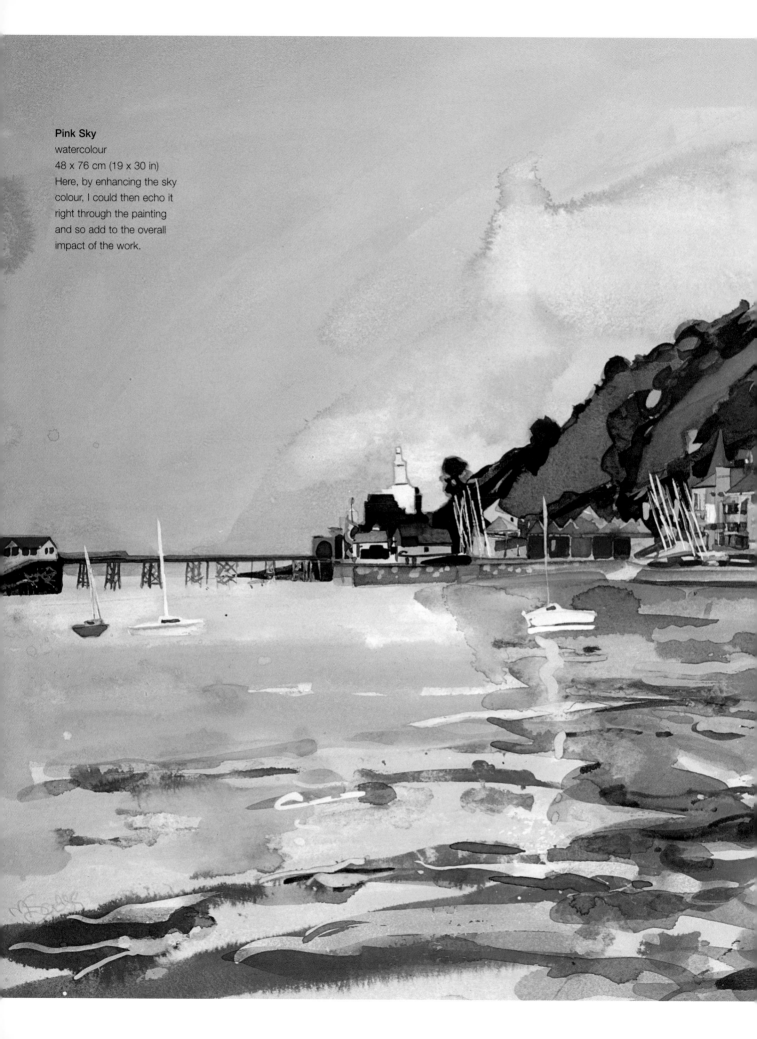

Pink Sky
watercolour
48 x 76 cm (19 x 30 in)
Here, by enhancing the sky
colour, I could then echo it
right through the painting
and so add to the overall
impact of the work.

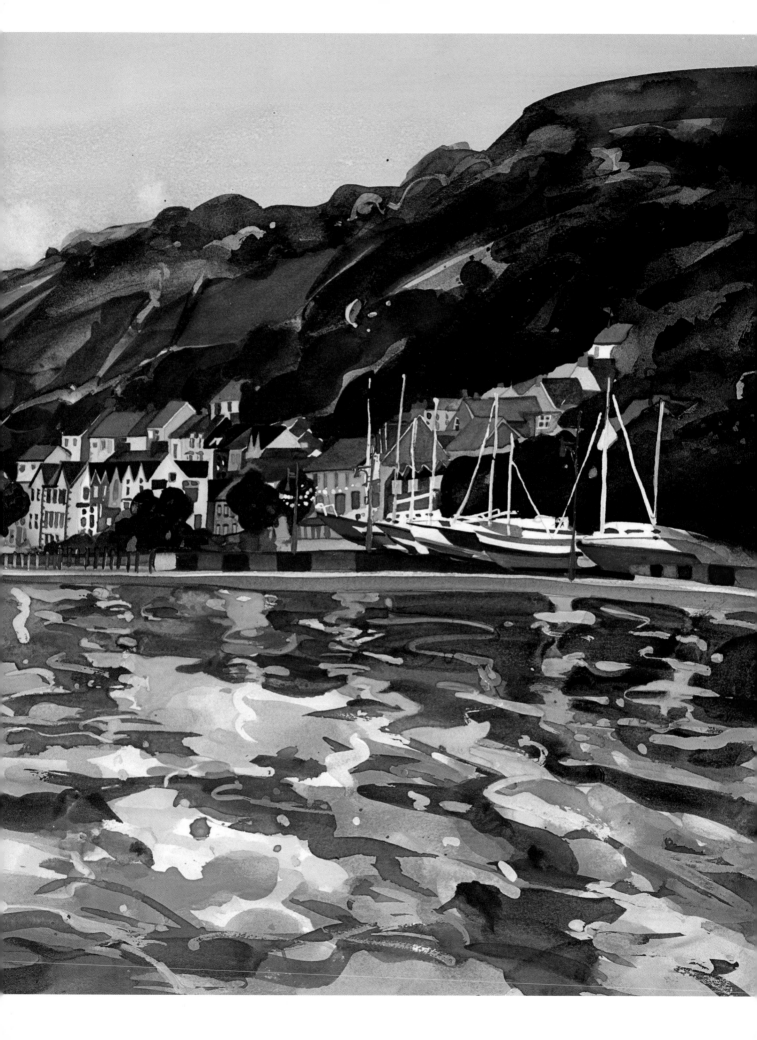

Challenging Subjects

My subject matter is wide-ranging and often, once I have painted something and seen its potential, I will go on to produce a substantial body of work that explores the theme – portraits, animals, flowers, abstracts and so on – in more depth. Variety is a good thing, I think, so my advice is not to limit your ideas too much, but instead try a different subject now and again. New challenges will also test your painting skills and help you improve. And remember that subjects do not necessarily have to be imposing or dramatic to inspire successful paintings. Simple subjects, expressed with some verve and feeling, often make the most powerful images.

Finding Subjects Outdoors

I used to paint and sketch outdoors quite frequently. Given the right subject matter and conditions, I felt that this approach – working on site with direct reference to the subject – could be extremely enjoyable and rewarding. As well as finding inspiration in the area in which I lived, especially on the Gower peninsula and around the Pembrokeshire coast, I also travelled extensively. In Malaysia, for example, groups of women in bright clothes made particularly exciting subjects to paint. Similarly in Tuscany, Spain and the Caribbean I found plenty of colourful ideas to interest me.

Although, when choosing a location for a painting trip I looked for places that had the potential for richly coloured thematic ideas, I usually travelled hopefully rather than with any specific subject matter in mind. In my experience, this is always the best approach: it leaves your mind open to whatever subjects and ideas you might find. If you plan a painting trip with set objectives, it is almost bound to be disappointing.

The same philosophy should apply to materials and equipment. My advice is to take a wide selection, so that you are prepared for every eventuality. After all, you can never be certain about the weather or other factors, so you might well have to vary the sort of work undertaken. For me, the most important aspect of such trips was always to collect as much reference material as I could – sketches and photographs that would, at a later date, support more resolved paintings made in the studio.

To work outside with confidence, you need to feel happy about the location and the general conditions, and it is well worth satisfying yourself in this respect before starting on a sketch or painting. I have never enjoyed painting in places where there are lots of people and consequently a risk of being observed and interrupted. For example, I can remember an occasion in Malaysia when I was making a sequence of sketches, and within about an hour there were at least 25 people around me! It is incredibly difficult to concentrate in such circumstances. However now, with experience, if I do need to research ideas outside I find I can work more efficiently and quickly, particularly if I start very early in the day, before most people are thinking of going out!

Circus Façade
watercolour and acrylic
51 x 71 cm (20 x 28 in)
Although in an abstract painting you are free to use shapes and colours as you wish, there is still the same need to create a design that has both interest and coherence.

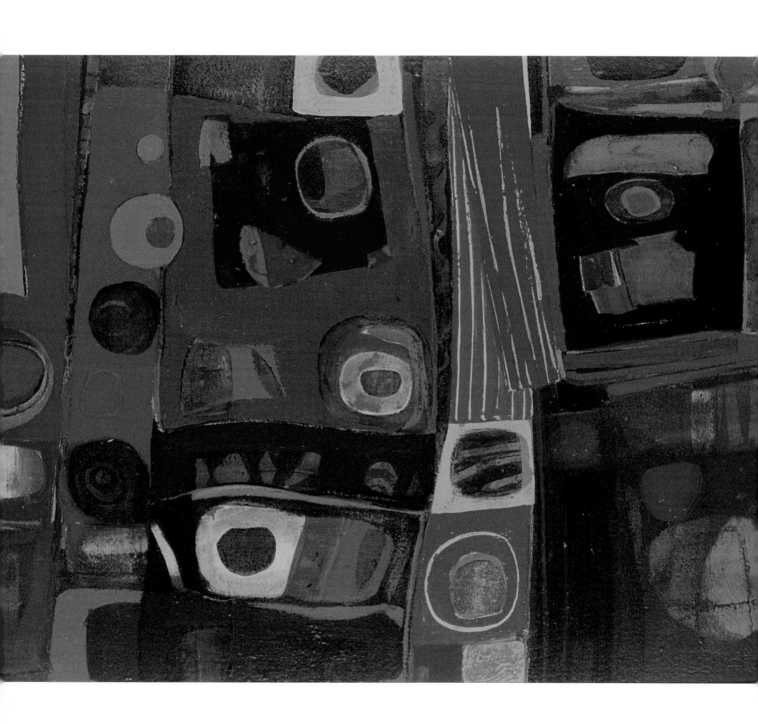

Landscapes, Figures and Animals

I prefer landscape scenes that include buildings, since these have more scope for creative design and the play of shapes and colours that is fundamental to my work. Mood and the sense of place are important to a degree, but I aim to express these through the use of colour, rather than wanting to capture a particular effect of light, for example. Nevertheless, light is always an influence, because it determines the actual colour key of the subject and its tonal variations. From the colours and tones that are there, I decide, through a process of selection and emphasis, how best to interpret the subject and create the impact I have in mind. *Malaysian Coastal Village* (right) and *Algarve Valley* (pages 102–103) are two examples of this approach.

With their ready-made patchwork of shapes and colours, townscapes provide an even better subject for me. Again, it is a matter of exploring and finding an interesting view, and then I simplify the jumble of rooftops, façades, towers, gable ends and so on to establish a coherent design, as you can see in *Pembroke Town* (page 104). I like the fact that a townscape can have an almost abstract quality about it and, as in *Mountain Village, Spain* (page 105), very little detail is necessary to make it work effectively.

It requires some experience to pick out the salient features of a subject and know how far to go with simplification. If you find this a problem, adopt a stage-by-stage approach: start with a sketch of the subject drawn as you would normally do, uninhibited by the need to simplify; then, using this sketch as your reference, make a further study in which you aim to focus only on the main shapes. If necessary, repeat this process until you have a design that is free of unwanted detail and allows you to concentrate on shape and colour.

Figures are another fascinating subject. As in *News-Stand, Florence* (page 106), I often paint ordinary

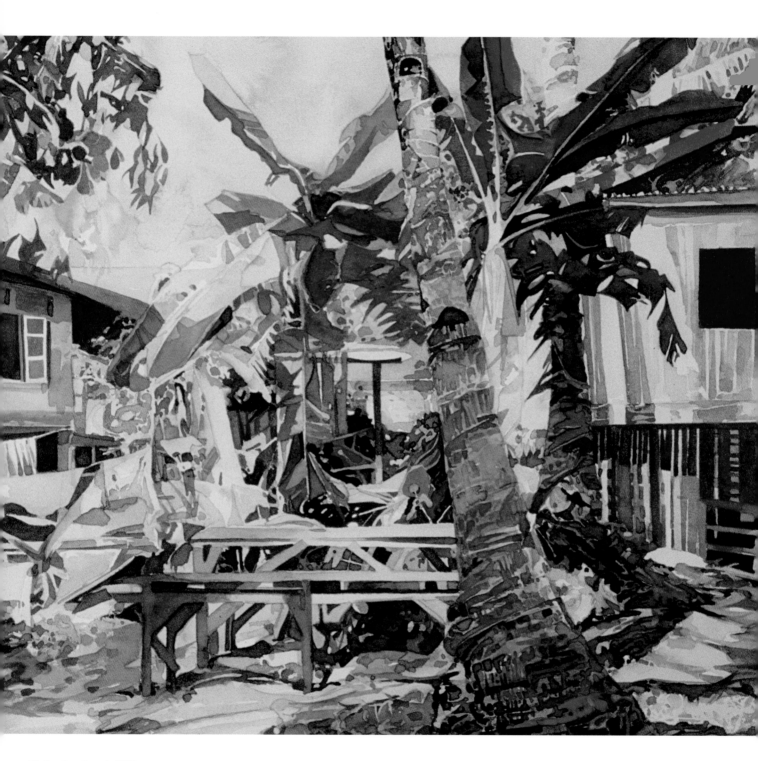

Malaysian Coastal Village
watercolour
35.5 x 76 cm (14 x 30 in)
On my trip to Malaysia I made numerous
sketches and colour notes, which I used
later as the reference for various studio
paintings, such as this one.

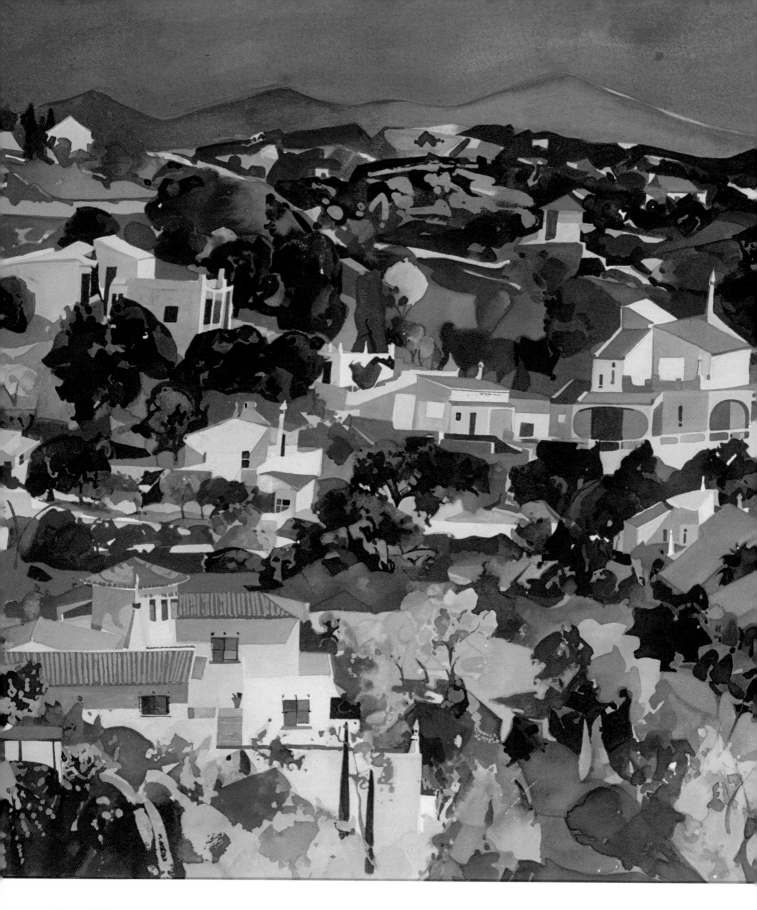

Algarve Valley
watercolour
71 x 117 cm (28 x 46 in)
With its ready-made patchwork of shapes and
colours, a townscape is the perfect subject for me.

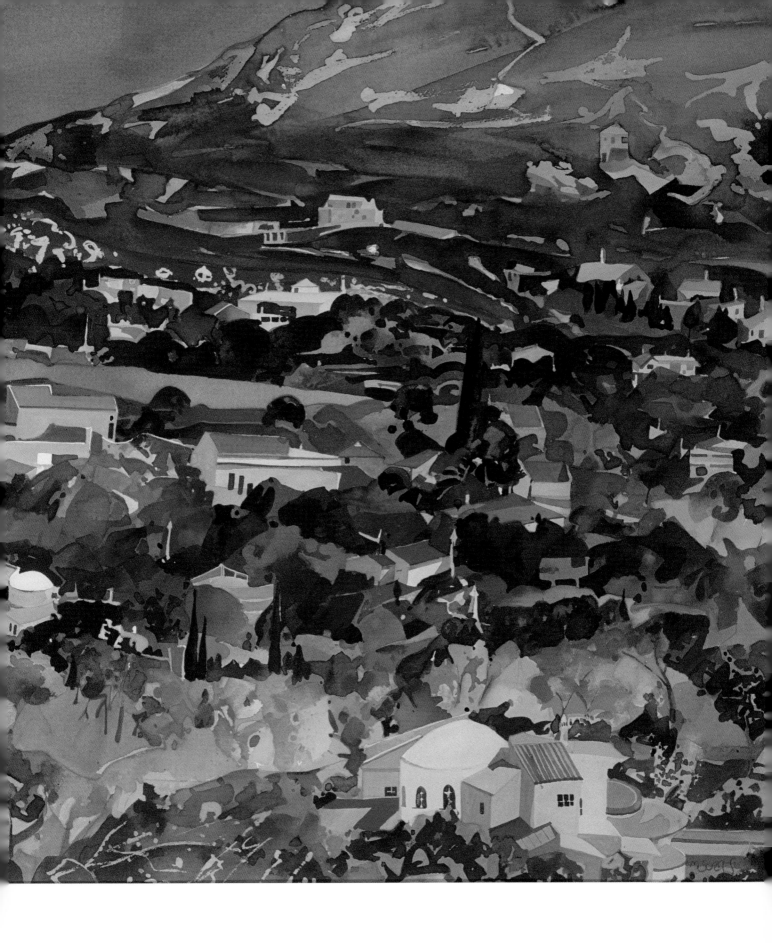

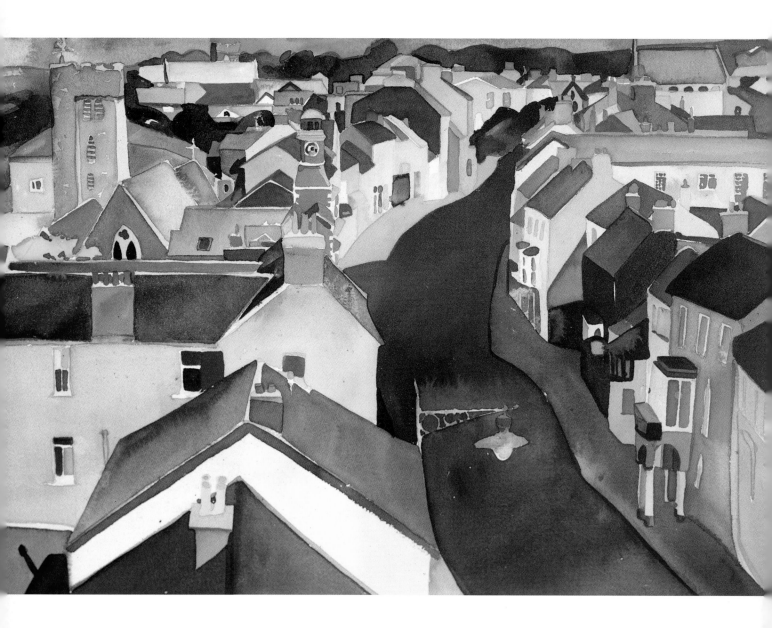

Pembroke Town
watercolour
46 x 61 cm (18 x 24 in)
The ability to pick out the
salient features of a subject
and decide how far to go
with simplification is
something that comes
with experience.

Mountain Village, Spain
watercolour
81 x 84 cm (32 x 33 in)
Inevitably, with a complex view,
in order to make the design
work effectively, the confusion of
rooftops, façades, gable ends
and so on has to be simplified
and, as necessary, adjusted and
reorganized.

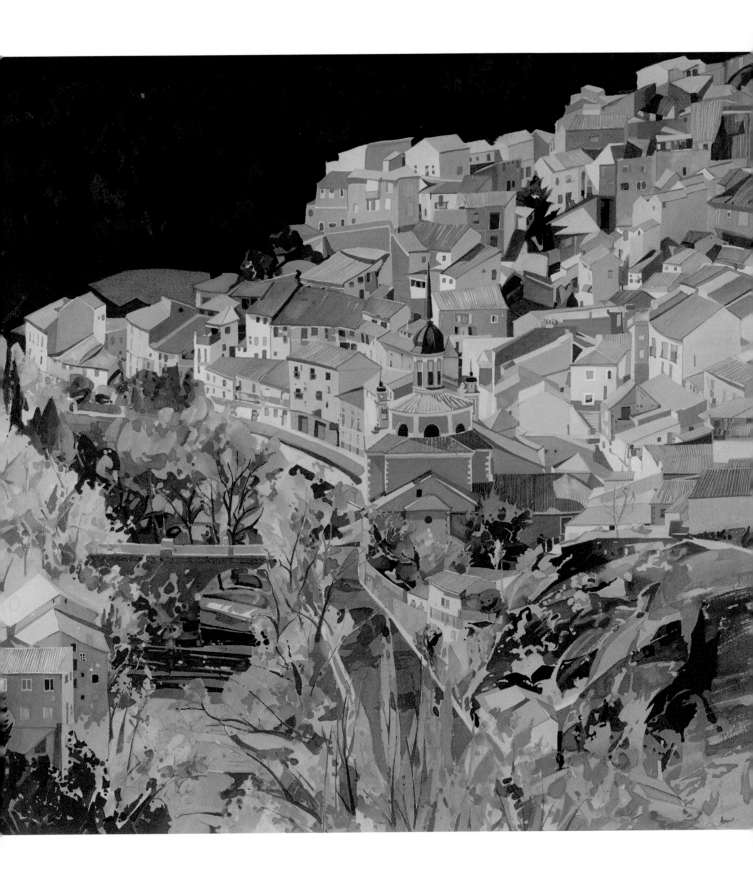

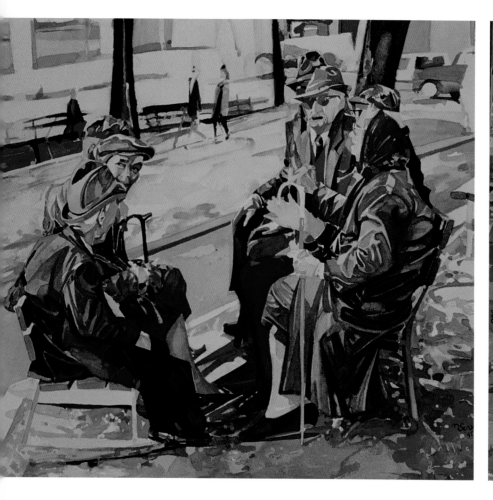

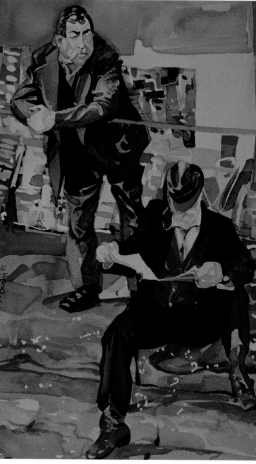

people or groups of people in their everyday environment. These groups make extremely interesting, engaging images, although as usual I will probably heighten or modify the colour scheme to some extent (note the limited palette in *News-Stand*) and simplify the content to ensure fresh, lively blocks of colour. The main difficulty with figures is getting them to look natural – a figure composition can so easily appear posed or contrived in some way. And this can be a particular danger if you only rely on photographs.

Because a figure or group of figures is unlikely to stay in place for very long, you have to act quickly if you are to record the image that you want. Some photographs are essential, but it is a good idea to back these up with a few quick sketches in which you note the particular features and characteristics that ought to be emphasized in the studio watercolour painting later on. Try making some colour sketches, working with a medium-sized brush and one or two watercolours. Then, when you work on the studio painting, aim to capture some of the verve and energy of the sketches.

Understandably, not everyone is happy about having their photograph taken by a complete stranger. In Malaysia, for example, I inadvertently upset a group of women in a market by taking their photograph; I was able to apologize, and they were further appeased when I offered to buy one of their large bags of fruit. There is no issue with photographs of groups and crowds taken from a distance, but for more close-up shots, especially of individual people, it is sensible and courteous to ask permission first.

Chatting, Italy (above left)
watercolour
43 x 56 cm (17 x 22 in)
Especially in a studio painting such as this, I am very conscious that I want the figures to look as natural and uncontrived as possible, and this is why I like to work as much from sketches as from photographs.

News-Stand, Florence
(above right)
watercolour
30.5 x 23 cm (12 x 9 in)
I enjoy painting ordinary people and groups of people in their everyday environment.

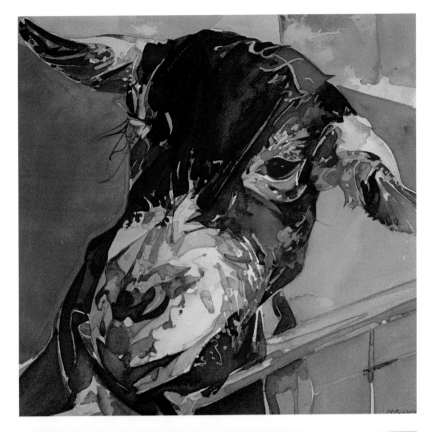

With animals, too, because they seldom stand still for very long, it is necessary to use a combination of sketches and photographs. I started with cockerels and, of course, colour was the initial attraction. Then, on a trip to Pembrokeshire, when I thought I would be mostly painting St David's and other townscapes, I visited a farm one day and was instantly inspired by the different animals I saw there. I gathered lots of reference information over the next few days and this led to a whole series of animal paintings.

I have also enjoyed painting horses at various race meetings. You might think that the crowds of people would deter me, but actually no one bothers me at these events: they are all too intent on watching the races. I love trying to capture the sense of movement of horses, which in a sketchbook can be achieved quite convincingly with just a few brushstrokes and blobs of colour.

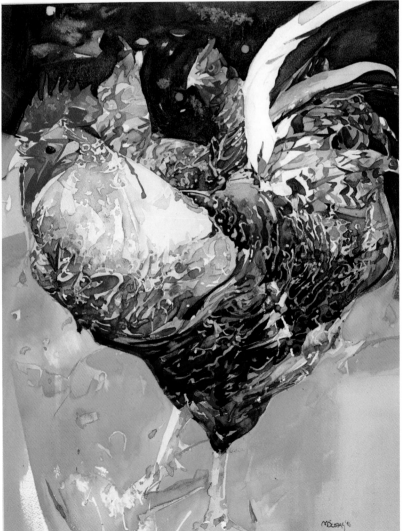

Goat
watercolour
35.5 x 40.5 cm (14 x 16 in)
A visit to a Pembrokeshire farm inspired me to paint a whole series of animals, including this inquisitive goat.

Speckled Cock and Hen
watercolour
61 x 46 cm (24 x 18 in)
With their wonderful rhythms of colour and tone, these birds are always a joy to paint.

Setting up Subjects in the Studio

My studio subjects include flowers, still-life groups and, especially now, many abstract paintings. Studio work is a real joy because no one is looking over my shoulder and I can work in comfort, with all my materials and equipment readily available. As I have explained, with flowers and still lifes, as with other subjects, there is always something that initially attracts my attention and creates the starting point for a composition. I may see a brilliantly coloured flower somewhere or a particularly interesting object that I want to paint, and then I build the composition around that.

As well as working in watercolour, I sometimes paint flower subjects using both watercolour and acrylic, and I also occasionally use oils. The painting process can take a long time, particularly if I decide to work on a large scale. *Poppies* (right), for example, is 91.5 cm (36 in) square, which is a big area to handle in watercolour, and *Roses* (page 111) is also a large painting. Both paintings took more than three weeks to complete and, as you can imagine, long before I had finished, the flowers had lost their perfect shape and freshness. Knowing this was likely to happen, I had taken some photographs for reference.

For *Poppies* I did all the initial work in watercolour, establishing the composition and building up the tonal variations with a series of colour washes. Then, for the finishing stage, I used acrylic paint, in some areas applying this as thin washes to strengthen the watercolour effects, and in other areas working with thicker paint to create contrasting passages of strong, opaque colour. Opaque acrylic colour is also useful for blocking out mistakes and reworking areas.

Another interesting feature of this painting is that it is painted on fine-weave canvas rather than paper, and this gives some lovely marks and effects. If you want to try this for yourself, ensure that the canvas is acrylic-primed (rather than oil-primed) and that you work with the canvas kept flat. Canvas is not as absorbent as paper and therefore the watercolour tends to sit on the surface for a while before it dries.

With still-life subjects I enjoy the opportunity to create an interesting design and concentrate fully on the effective use of colour. I regard these paintings as essentially about proportion and colour. For *Grapes* (page 110) I started the painting outdoors, doing as much as I could from direct reference to the subject before adding the final touches in the studio. In contrast, *Apples* (page 112) was painted from an arrangement set up in the studio, and here I have used a limited palette of colours to give a strong sense of colour harmony.

Poppies
watercolour and acrylic
91.5 x 91.5 cm (36 x 36 in)
I paint from real flowers, but obviously over
a period of time they tend to lose their
perfect shape, and therefore I also rely on
reference photographs.

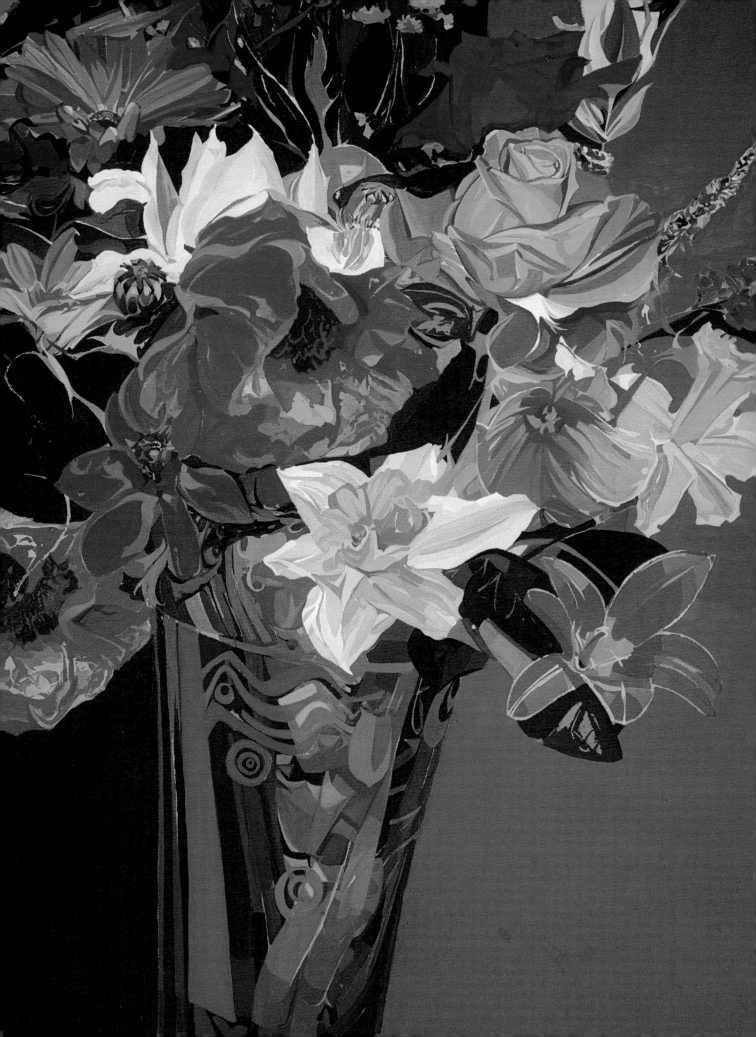

For an abstract painting, such as *True Colours* (page 112), there are several different ways that I might start. For instance, I sometimes find inspiration in previously painted abstracts, taking a small section of the design and enlarging it significantly to create a new work with its own visual dynamism and colour emphasis. Or I might start with a freely expressed drawing of some kind, to suggest shapes and lines that I can use in a more controlled fashion, in conjunction with a certain choice of colours, to make an exciting abstract design.

Additionally, there are ideas that start in a fairly representational way but which subsequently lead to an abstract interpretation. Now that I have a studio in Bath, as well as painting views looking over the town, I also aim to use this same subject as the starting point for abstract work.

Grapes
watercolour
58.5 x 48 cm (23 x 19 in)
As here, it is sometimes possible to start a painting outdoors and then add the finishing touches in the studio.

Roses
oil on canvas
132 x 51 cm (52 x 20 in)
This large painting took over three weeks to complete and so required some back-up photographs for reference.

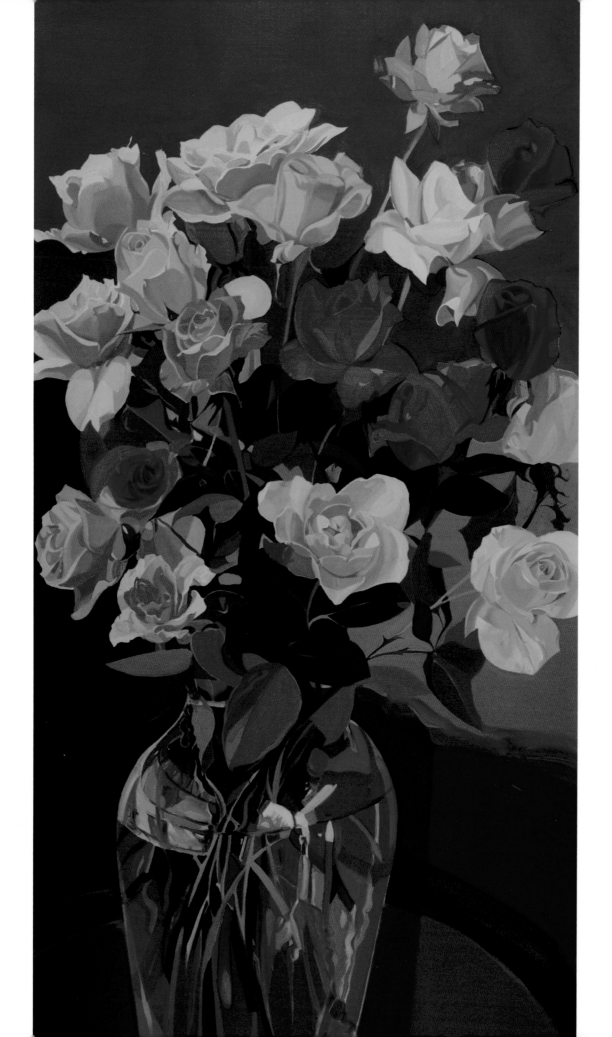

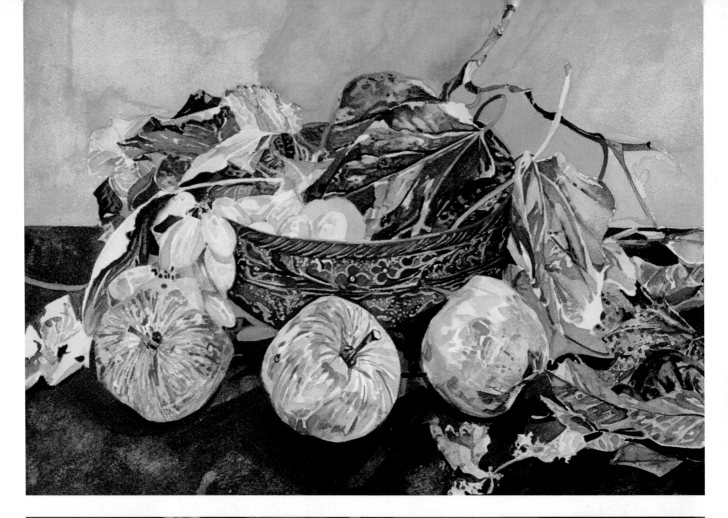

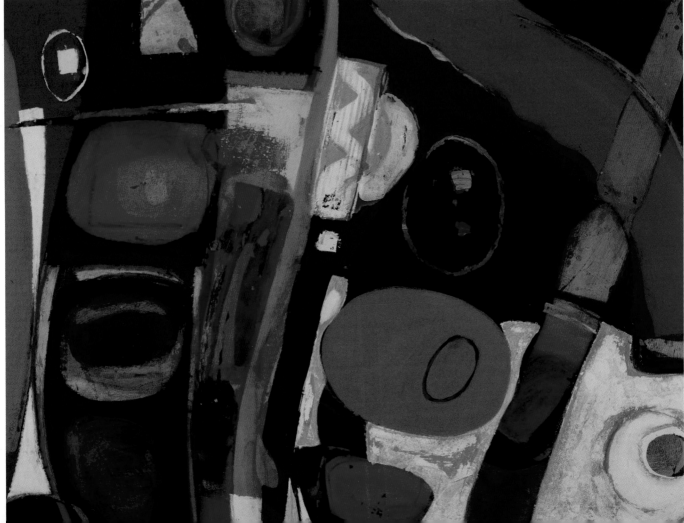

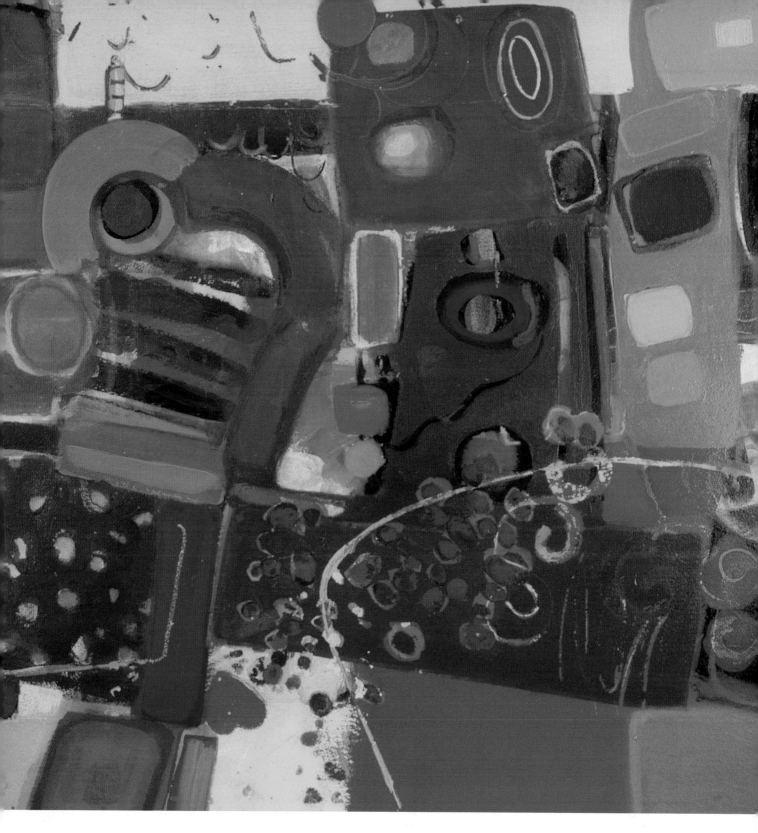

Apples (top left)
watercolour
23 x 30.5 cm (9 x 12 in)
Working with a very limited palette of colours gave this painting a strong sense of harmony as well as the appropriate autumnal quality.

True Colours (bottom left)
watercolour
51 x 71 cm (20 x 28 in)
For this type of abstract work I usually start directly with a brush to make some incidental coloured marks or shapes. These probably will not stay, but initially are useful as a means of inspiring an idea to develop.

Primary Colours (above)
watercolour
104 x 104 cm (41 x 41 in)
With abstracts, there is more of an opportunity to involve texture as well as colour in the design.

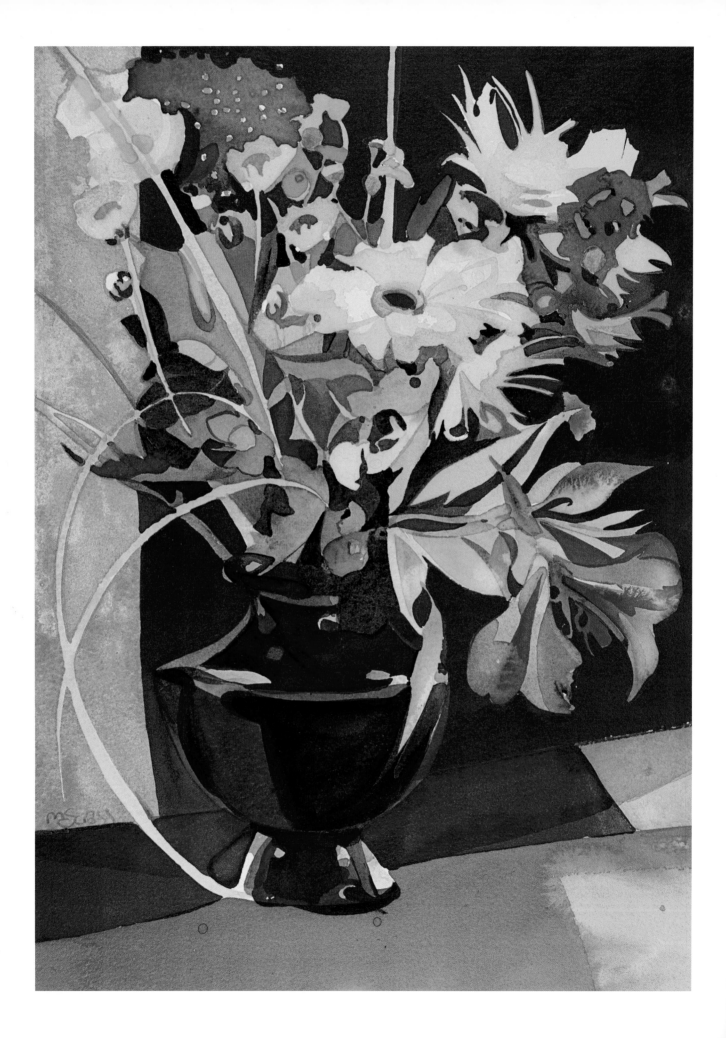

Studio Practice

I still occasionally make sketches and colour notes on location, when these are necessary for the particular project that I am working on, but most paintings are entirely studio-based. This is increasingly so now that I am concentrating more on abstract paintings. Sometimes I have two or three paintings in progress at the same time, perhaps especially when I am working in oils, but generally I like to focus on one idea.

Having started a painting and become involved with it, I am very reluctant to leave it until the work is finished. And because of this, once I am totally preoccupied by a painting, I seldom stop to clean or tidy anything and so it is not long before I am surrounded by chaos. However, I always begin with a completely tidy and well-organized studio!

Selection and Emphasis

Decisions associated with selection and emphasis run right through the painting process, starting with the choice of subject matter and finishing with the touches of colour and detail necessary to ensure the unity and impact of the work. That first decision – the choice of subject matter – might seem to be the most important one, but in fact it is how you elect to interpret the subject that ultimately proves the more telling decision. Inevitably, as you develop the painting, in order to create the response that you have in mind, there will be times when something needs simplifying or perhaps even ignoring, and times when you need to draw attention to a colour, surface quality or particular detail by emphasizing it.

Those decisions will be governed by your own feelings about the subject and the aspects of it that you particularly wish to focus on. Equally, the decision-making process will be influenced by the painting itself. As you paint, perhaps a colour relationship, brushmark or effect somewhere will suggest a slightly different emphasis to explore than the one that you had intended.

So, although it is wise to have an objective for each painting, my advice is not to be too bound by your initial idea. One of the most significant things that I have learned from painting is to avoid firm preconceptions about how an idea should be developed. I like to keep an open mind and I am not afraid to let the creative process take over. Essentially, in my work I tend to exaggerate tonal and colour qualities, while the process of selection will usually apply to aspects such as content, shape and detail within the chosen subject matter.

Yellow and Pink Floral
watercolour
51 x 28 cm (20 x 11 in)

Stargazer
watercolour
23 x 76 cm (9 x 30 in)
Although the subject matter is always an important element in contributing to the success of a painting, usually the most significant factor is the way that you interpret what you see.

From Alexandra Park, Bath (Stage 1)
Working from my reference sketch and the photographs,
I started by making a careful drawing on watercolour paper
of all the groups of buildings.

From Alexandra Park, Bath (Stage 2)
Initially I worked on decisions about the colour palette and
tonal range for the painting.

From Alexandra Park, Bath (Stage 3)
Next I added the lightest green areas to complete the range
of tones and colours that I intended to use.

From Alexandra Park, Bath (Stage 4)
With most of the colours now blocked in, I was able to start
adjusting the tones in places by wetting and lifting out colour
or adding more layers of colour.

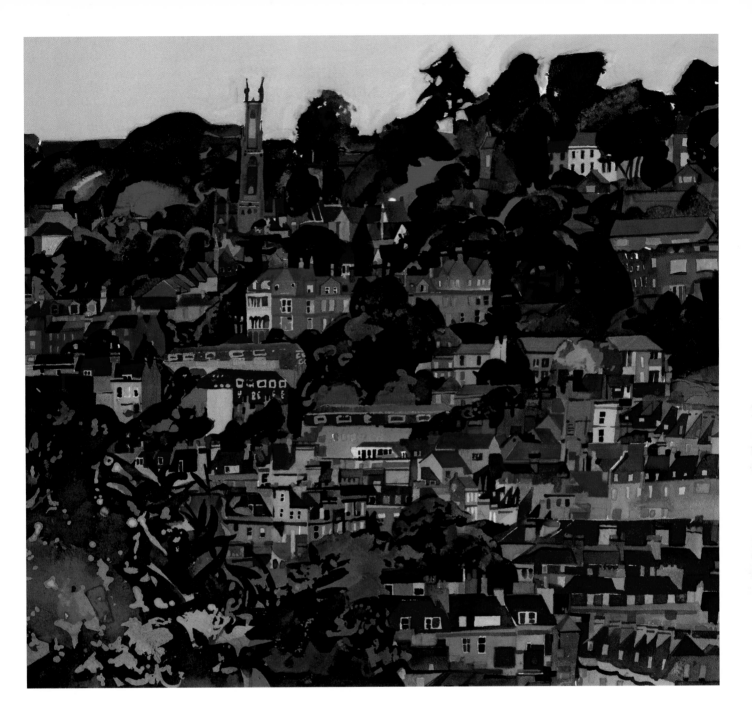

From Alexandra Park, Bath (Stage 5)
watercolour
56 x 61 cm (22 x 24 in)
Finally I added the sky colour and emphasized the tonal contrast and variety in the foliage areas.

Starting from Reference Material

For landscape and townscape views, such as those chosen for the two demonstration paintings illustrated on pages 119–121, I usually start by making some sketches on site and taking a series of photographs. These, together with my own experience and memory of the scene, will give me sufficient reference material from which to work on a studio painting.

But first I have to find a good viewpoint – one that offers plenty of scope to develop the design and colour aspects of the subject. For *From Alexandra Park, Bath,* I deliberately sought out a view in which areas of foliage punctuated the mass of buildings. I knew that these patches of green would create the perfect contrast to the warm tones of the buildings and at the same time provide areas of rest, so that visually the painting did not become too busy.

Back in the studio, as you can see in Stage 1 (opposite), I began by making a light pencil drawing on the watercolour paper to plot the position of the various groups of buildings. Usually I am wary of doing a lot of drawing, because it can encourage too much detail.

However, in this case it was important that the grouping and shapes of the buildings were clearly defined, as they were not the sort of shapes that I could add freely with a brush. I worked on unstretched Arches 850 gsm (400 lb) Rough watercolour paper.

I decided on a limited colour palette, using fairly high-key colour based on warm pinks and terracottas for the buildings and complementary blues and greens for the roofs and foliage. I began with the tall church tower (Stage 2, page 116), which in fact is the focal point of the painting, using a rich pink for the stonework and a soft cobalt blue for the arched window. Next, it was important to assess the tonal range for the painting, and this accounts for the other blocks of colour that are included at this stage – the strong darks at the top, for example, the mid-greens, and the more subtle tones on the left-hand side.

Now I was able to judge the lightest green areas (Stage 3, page 116) and, with the tonal range and selected colour palette in mind, move on to block in almost the entire picture surface (Stage 4, page 116). Also at this stage, I decided to liven up the large area of green on the left-hand part of the foreground. I wetted and lifted out some of the colour by blotting it with kitchen paper, and then, while the paint was still slightly damp, added a touch of yellow and allowed it to bleed into the existing colour.

I worked with a variety of brushes. The large foreground areas of green, for example, were painted with a 3.8 cm (1½ in) flat brush, while for some of the windows I used a very fine sable brush. Essentially, the painting was built up from individual blocks of colour, each clearly defined yet working in relation to those around it and to the composition as a whole.

To achieve the intensity of colour and tone in some areas I applied more layers of colour, as many as five layers in places, painted wet-on-dry. And finally I added the sky colour and emphasized the tonal contrast and variety in the foliage areas, especially in the foreground (Stage 5, page 117). However, on reflection I think I have overworked some of the green areas. It is never easy to judge exactly when to stop, but perhaps for this painting I should have stopped a little sooner!

For *Langland Bay,* (pages 119–120), which was a commissioned work, I adopted a similar approach, although for this painting, due to its size, there were a number of technical difficulties to overcome. Because of the size required, I had to join two sheets of Arches Aquarelle paper together, and in turn this created some problems in actually handling and working on the painting, as well as when it came to mounting and framing it. In fact, I decided to 'float' the finished painting in the frame rather than use a traditional mount, and back it with acid-free foam board. The join between the two sheets of paper does show slightly, but it would have been more obvious had the work been mounted in the conventional way.

My viewpoint for this painting was from the golf course overlooking the bay and, on site, I made a large sketch on a sheet of card, jotted down some colour notes, and took a series of digital photographs. I printed the photographs and joined them together to show the panoramic view that I wanted to re-create in my painting. Also, as I used to live in this area and I have painted similar views in the past, I knew my knowledge and experience of the subject would help.

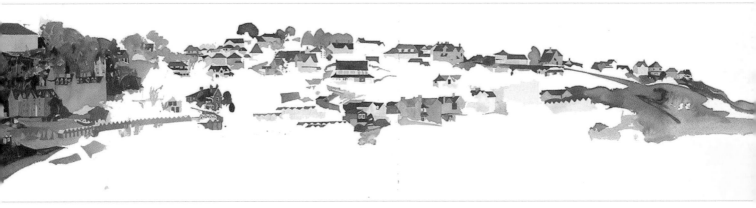

Langland Bay (Stage 1)

After making just a few pencil guidelines, I began blocking in the central area of buildings with watercolour.

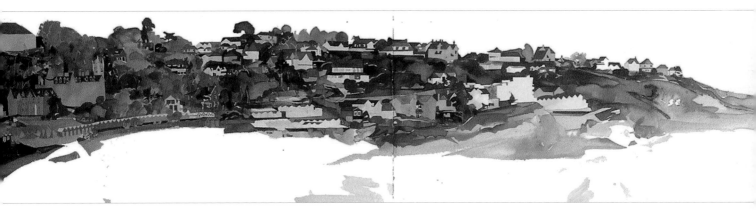

Langland Bay (Stage 2)

I added the various green tones and also applied drops of masking fluid to the beach area where, later, I intended to include umbrellas, figures and so on.

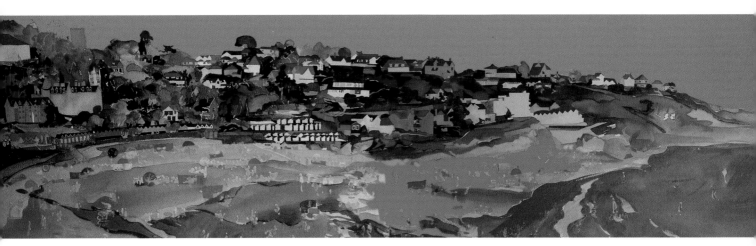

Langland Bay (Stage 3)

With large, flat brushes, I worked on the foreground beach area and decided on the two blues for the surrounding sea and sky.

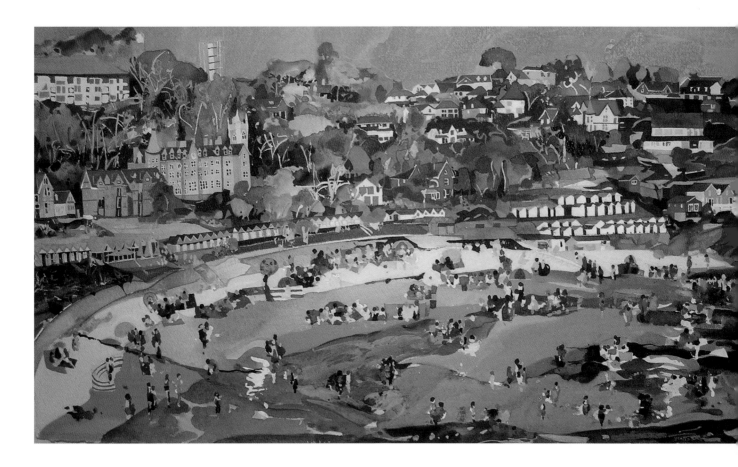

Langland Bay (Stage 4)
watercolour .
53 x 203 cm (21 x 80 in)
I rubbed off the masking fluid and added the detail for the beach area, finally
introducing some dark tones to unify the composition.

Due to the scale of the project and my familiarity with the subject, I felt I could work
quite freely, and therefore I needed only the minimum of pencil guidelines to give me a start.
Next I began blocking in the buildings in the busy central area of the composition (Stage 1,
page 119) as usual at this stage, making decisions about colours and tones that would
provide a useful reference from which to develop the rest of the painting.

I worked further on this section of the painting, filling in the various green areas and
aiming to create an interesting overall balance of shapes and tones (Stage 2, page 119). Also,
I began to consider the foreground beach area and added little dots and blobs of masking
fluid here and there to indicate the people, umbrellas and other beach items and activity that
I wanted to protect from any subsequent colour washes.

Then, using large, flat brushes and long brushstrokes (Stage 3, page 119), I blocked in the
foreground beach area with warm ochres, reds and yellows, which complemented the

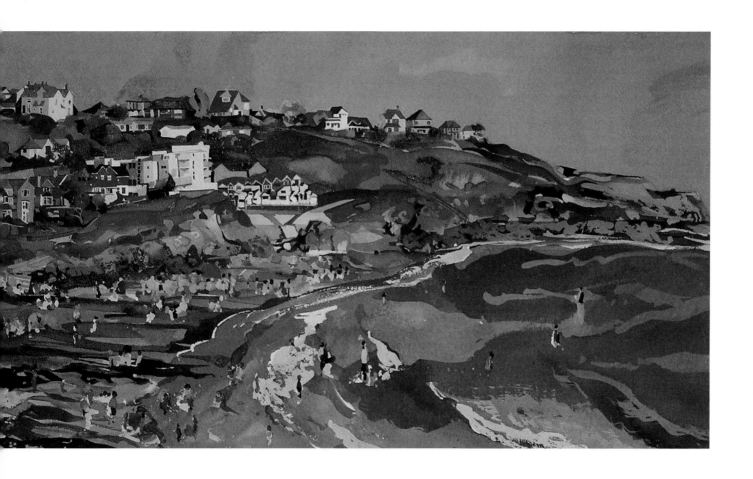

surrounding blue of the sea and sky. In fact, I matched the blue of the sea to one of the tones that I used for the roofs of the houses in the middle section of the painting, thus helping to create a link between the two areas. And for the sky, to give a sense of pictorial space and create a satisfactory tonal balance in the painting, I chose a lighter blue.

Finally (Stage 4, above), I rubbed off the masking fluid and worked on the detail for the beach area, and also added touches of colour to other parts to help unify the composition. In the foreground, for example, there is a very dark tone used for the rocks and shadows in the sea, which I have repeated on some of the buildings and other areas to draw the viewer's attention into and around the painting.

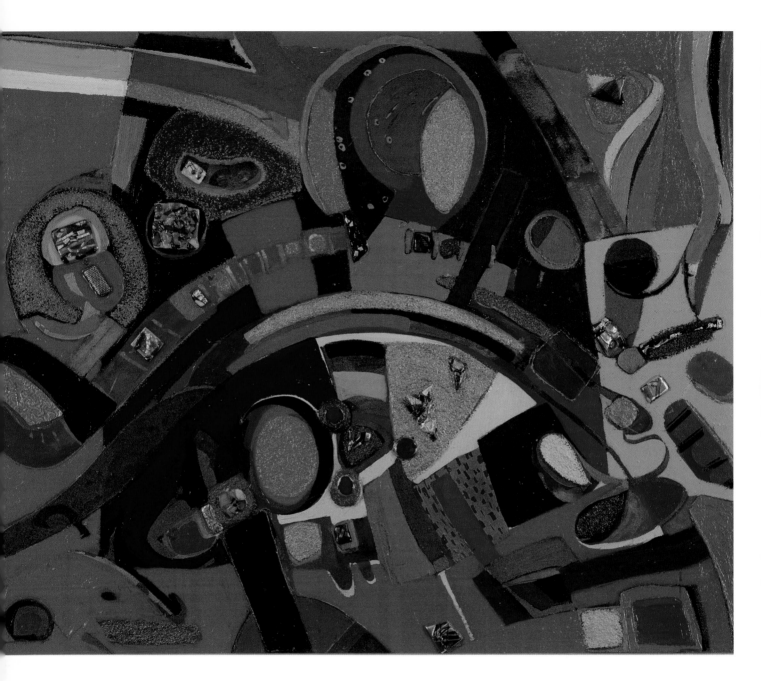

Colour and Design

As I have stressed in other parts of this book, for me, the fundamental concerns in painting lie with shapes and colours. This approach applies equally to a representational work, such as *Chanel* (opposite), as it does to a totally abstract idea, such as *Firecracker* (above). In both types of work, the degree of success depends on the basic design – the way that the idea is presented, including its scale and format (note the tall portrait format used for *Chanel*, for example) – and in conjunction with this, the use of carefully considered colour relationships.

In addition, tone, proportion and rhythm are important elements when developing a painting. These elements significantly influence the mood, interpretation and impact of each work, and they are particularly relevant to abstract compositions. For in abstract paintings

the content cannot imply a form of narrative or meaning in the same way that it does in, say, a landscape or a still-life painting. Instead, the impact of the painting relies totally on the dynamics of shape, colour and surface qualities. Essentially, the concerns and decisions relate to the choice of shapes and their size, spacing and relationship, and the choice of colours and how these contrast or harmonize and create a rhythm and flow of interest through the work.

Exciting Abstracts

When I first became interested in making abstract paintings, about two years ago, I used to begin in a very direct way, with freely applied marks and colours, perhaps not preserving those initial marks, but using them to inspire a way forward with the work. However, now I prefer a more organized approach that will give me some kind of prop or reference from which to develop the painting.

I like to know the broad layout, proportions and dynamics of the idea, and usually this takes the form of a preliminary watercolour sketch. I might try a number of ideas before I am ready to work on one of my large paintings, and in many of these I now start with watercolour but then, as the creative process takes over, I develop the painting extensively using acrylic colours.

Silver Twist is an example of this way of working. The starting point was one of my young daughter's drawings that I had kept. I added to it slightly, with a few marks of my own, as shown in Stage 1 (page 124). The actual painting was made on a sheet of MDF (medium-density fibreboard); this initially, as part of the design process, had some lines carved into its surface, and was then sized and primed with acrylic primer.

The first marks that I made on the board, to indicate the basic design that I wanted to work from, are shown in Stage 2 (page 124). Some of these lines were made with red watercolour, others with a mixture of red ink and acrylic paint. I decided to use a colour palette based primarily on pinks, reds and silver although, as the painting developed, other colours were introduced. The preliminary blocking-in stage (Stage 3, page 124) was made in watercolour and then, as I started to refine and enhance the colour relationships (Stage 4, page 124), I worked in acrylic.

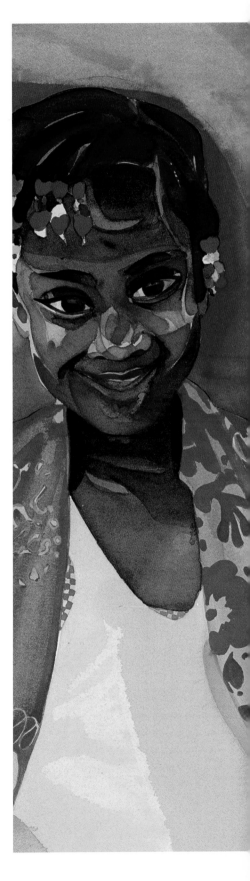

Silver Twist (Stage 1)
This drawing by my young daughter, to which I added some marks of my own, was the inspiration for the painting.

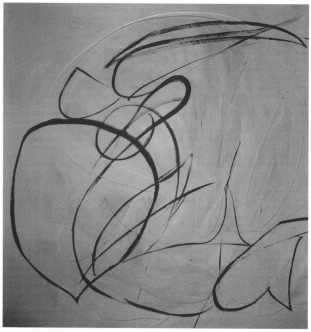

Silver Twist (Stage 2)
For these first lines, which I made to give me a sense of the design, I used a mixture of watercolour, ink and acrylic.

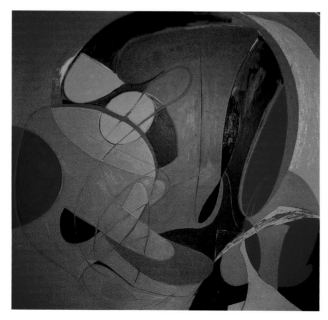

Silver Twist (Stage 3)
I started by blocking in the main shapes, initially in watercolour and then working over them in acrylic.

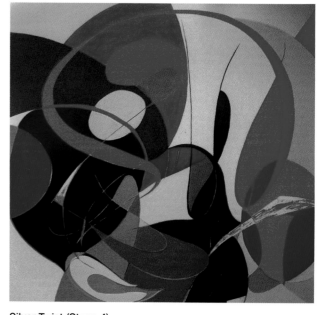

Silver Twist (Stage 4)
Now working exclusively in acrylic, I began to refine most of the shapes and colours.

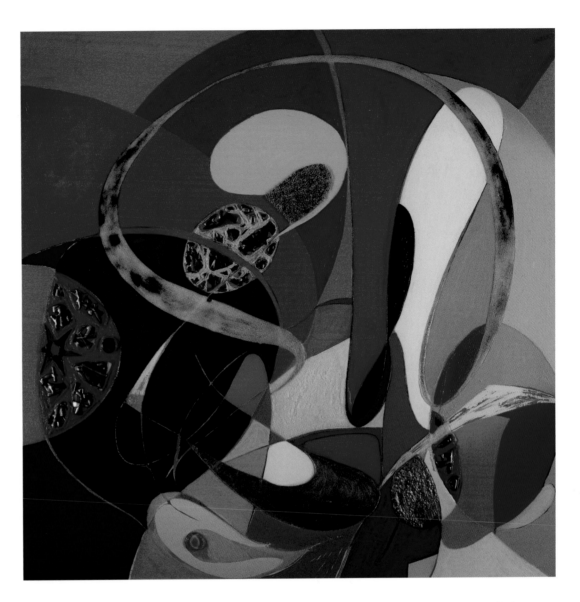

Silver Twist (Stage 5)
watercolour, acrylic, resin and glass on MDF board
137 x 140 cm (54 x 55 in)
After further work on the balance and relationship of colours, I added resin to the incised parts of the board to enhance the silver twist motif with a glass-like quality.

Watercolour, and particularly acrylic paint, takes to a primed MDF surface quite well, but it is necessary to use paint of a reasonably thick consistency if, as I did in this painting, you want sharp, flat areas of colour.

Next I began to introduce texture to some of the shapes to create areas of contrast. For this stage, I used reflective glass beads and other shapes, which were attached to the surface with adhesive and then secured further by working texture paste around each shape. For the green oval area (slightly above-left of the centre in the design), I used beads that were fixed with the heat from an iron and then painted with clear varnish.

To achieve the mood and impact of colour that I had in mind for this painting, I made quite a few adjustments to the colours in the final stage (Stage 5, above). The main task now was to create an exciting balance of reds, and it took some time to develop the correct weight and relationship of colours.

Then, to complete the painting, I added resin to the lines that had been carved out from the surface. I used a clear resin for some lines and a more viscous, frothy resin for the main 'silver twist' motif that encircles the central part of the painting. This added a glass-like quality to these areas and another contrasting texture. The finished work was varnished with a clear acrylic varnish.

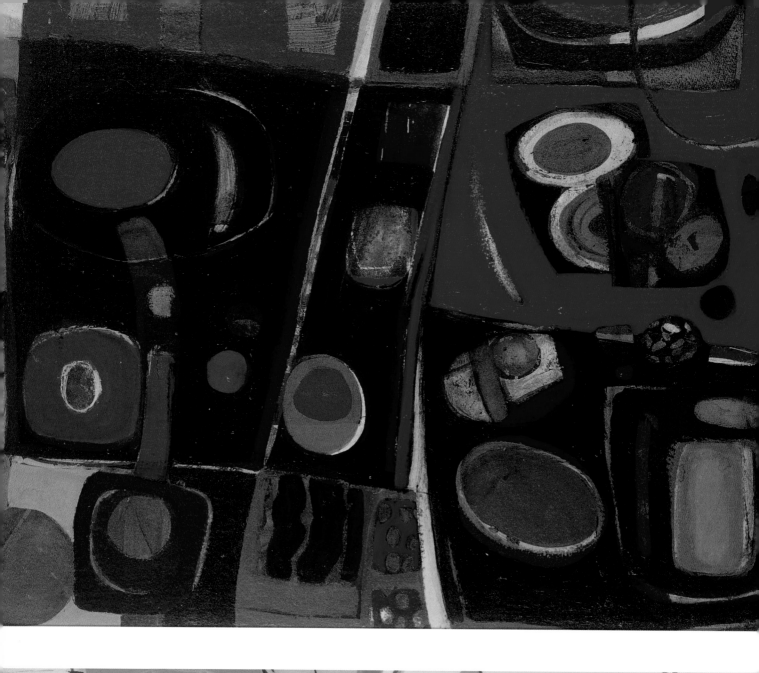

Visual Impact

Marina
watercolour and acrylic
71 x 51 cm (28 x 20 in)
The impact of an abstract
painting such as this relies
totally on the dynamics and
relationships of shape, colour
and surface qualities.

Rhythm
watercolour, acrylic and resin
56 x 236 cm (22 x 93 in)
Currently I am mainly
interested in making large
paintings in which I can
explore colour and texture in
various ways, principally using
acrylic paints, but I am sure
that watercolour will always
play a part in my work.

Watercolour is an impressive, versatile medium; it offers immense freedom, either to paint with a good degree of control, or to use a more spontaneous, expressive approach. Contrary to the view that many people hold about watercolour, its particular strengths and advantages lie not only in its ability to be worked as subtle, translucent washes, but also in the fact that, when required, it will give vibrant, pure colour. This is how I like to use watercolour, and for me the challenge with every painting is to achieve a fresh, jewel-like quality with the colour, so that it is both an emotional and a descriptive force within the work.

One of the most difficult decisions to make in a painting is judging when to stop, for it is vital to stop before the painting becomes overworked and thus loses its energy and impact. Equally, this can happen during the painting process if too much detail is included. Sometimes it can be a good idea to put the painting aside for a day or two and then have a fresh look at it to decide what, if any, further work should be done. Also, I think there is value in inviting other people to look at your paintings occasionally and to offer their opinion about the strengths and weaknesses in your work. Choose someone whose judgement you respect.

Generally, the most successful paintings are those in which there is a strong sense of design, interesting colour contrasts and harmonies, and confident brushwork and paint-handing effects. Also, it is important that the content is original and expressed in a personal way. My approach to painting may differ from your own, but I hope nevertheless that you have found this book interesting and inspirational. Whatever your style of work, what matters most is that you feel comfortable with it; that you are true to yourself. Whether you adopt an abstract or a representational approach, I hope you experience as much enjoyment and reward from the challenge of painting as I do.

Index